The Wilderness Within

American Women Writers and Spiritual Quest

Kristina K. Groover

THE UNIVERSITY OF
ARKANSAS PRESS
Fayetteville
1999

03 02 01 00 99 5 4 3 2 1

Designed by Liz Lester

⊛ The paper used in this publication meets the minimum require-
ments of the American National Standard for Permanence of Paper
for Printed Library Materials Z39.48-1984.

Library of Congress Cataloging-in-Publication Data

Groover, Kristina K., 1961–
 The wilderness within : American women writers and
spiritual quest / Kristina K. Groover.
 p. cm.
 Includes bibliographical references and index.
 ISBN 1-55728-557-8 (cloth : alk. paper). —ISBN
1-55728-563-2 (paper : alk. paper)
 1. American fiction—Women authors—History and
criticism. 2. Psychological fiction, American—History and
criticism. 3. Domestic fiction, American—History and
criticism. 4. Women and literature—United States—History.
5. Quests (Expeditions) in literature. 6. Wilderness areas in
literature. 7. Spiritual life in literature. I. Title.
PS374.W6G76 1999
813.009'9287—dc21 99-11749
 CIP

The
Wilderness
Within

Acknowledgments

Regardless of what the title page may say, the true story of this book's evolution is found here, in the acknowledgments. I could not have written this book without many kinds of help and support, and it is a great pleasure to thank those who provided it.

I am deeply grateful to Linda Wagner-Martin, my advisor at the University of North Carolina at Chapel Hill, for her astute and willing advice and her kind friendship. She faithfully shepherded me in my circuitous path through graduate school, supported this project at every stage, and continues to serve as mentor and friend. Thanks also to Townsend Ludington and Fred Hobson for their generous support and guidance during my graduate career.

I am indebted to a number of other teachers who have encouraged me in my work. At Dickinson College, the skillful teaching and intellectual energy of Sharon O'Brien, Bob Winston, and Ellen Rosenman first inspired me to undertake an academic career. I thank them for pushing me to do my best work and for encouraging me to imagine myself as a teacher and scholar.

Perhaps the most fortunate turn of my academic career has been the one that landed me in the English Department at Appalachian State University. Here I work in a congenial atmosphere among colleagues who are also friends, and I owe much of my productivity and my personal and professional happiness during the past several years to their support, assistance, and encouragement. Several of my colleagues deserve special thanks. Lynn Sanders and Susan Staub have championed my academic career from its very beginnings, and I thank them for their generosity in word and deed. Grace McEntee and I have shared many

helpful conversations about teaching and writing, conversations which have often been followed up by an article or reference slipped into my box with an appended note: "Does this help?" Rosemary Horowitz and Kathryn Kirkpatrick have been my most demanding and supportive readers; they have struggled along with me over the ideas discussed in this book, and I thank them for their generous collegiality and their sustaining friendship.

I am grateful to my parents for many kinds of support, especially for not insisting that I do something more practical, and to my sisters for their interest in all that I do and for their irreverent good humor. Communities of friends in Chapel Hill, Durham, Lynchburg, and Boone have helped me to keep my life on an even keel, both by cheering me on and by cheerfully reminding me that most of the world doesn't revolve around academia.

Cady kept me company by sleeping under my desk during long hours of writing and by seeing to it that I had lots of walks. And my deepest thanks go to Marian Peters, for being my family.

Contents

Chapter I

Introduction: Re-visioning the Wilderness

Women have no wilderness in them,
They are provident instead,
Content in the tight hot cell of their hearts
To eat dusty bread.

—Louise Bogan

The notion of spiritual quest as the quintessential American experience is central to both American mythology and literature. Throughout the American literary canon, heroic protagonists undertake physical journeys whose destination is a greater understanding of or connection to the spiritual world. Early Puritan texts depict the English colonists' literal sojourn in the New England wilderness as a spiritual descent into the wilderness of the soul; these early settlers named themselves "Pilgrims," thereby mythologizing themselves as modern-day Israelites in a strange and hostile land. In the mid-nineteenth century, when Puritanism no longer dominated the imaginations of most American writers, a pervasive concern with soul, spirit, and metaphysical experience continued to mark the writings of the Transcendentalists and their inheritors. And, despite the break with tradition that distinguishes much twentieth-century American literature, many works from the modernist canon suggest a continued preoccupation with a spiritual realm.

Twentieth-century incarnations of the frontier reveal the intersection of the physical and spiritual, the literal and the psychic to be found in the wilderness quest. The crowded but spiritually void urban landscape of T. S. Eliot's *The Waste Land,* the burned-out wilderness Nick Adams encounters in Ernest Hemingway's "Big Two-Hearted River," the blank hole inhabited by Ralph Ellison's Invisible Man, and even the "final frontier" of space in contemporary science fiction reflect a preoccupation with the spiritual emptiness of the modern age and the quest for meaning beyond the temporal world.

Although the centrality of the wilderness myth in American arts and letters seems self-evident to most American literary scholars today, David Mogen points out in his introduction to *The Frontier Experience and the American Dream: Essays on American Literature* that scholarly interest in the "Americanness" of American literature represents a relatively recent phenomenon. Before evolving as a recognized field of literary study in the mid-twentieth century, American literature was viewed largely in terms of its indebtedness to the European tradition. In 1950, however, Henry Nash Smith's *Virgin Land* examined the American literary tradition in terms of Frederick Jackson Turner's "frontier thesis," which suggested, writes Smith, that "the West . . . was the most important among American sections" and that American society had been most definitively shaped by "the novel attitudes and institutions produced by the frontier" (292). In *Virgin Land,* Smith explores the implications of Turner's thesis for literary studies, examining the centrality of the frontier quest in nineteenth-century literary works from James Fenimore Cooper's Leatherstocking tales to Walt Whitman's American manifesto, *Leaves of Grass.* Smith's text inaugurated a critical tradition which includes seminal works of the past several decades, including Richard Chase's *The American Novel and Its Tradition* (1957), Leslie Fiedler's *Love and Death in the American Novel* (1960), Harold Simonson's *The Closed Frontier* (1970), and Richard Slotkin's three-volume series, *Regeneration through Violence* (1973), *The Fatal Environment* (1985), and *Gunfighter Nation* (1992).

In *The American Adam,* published in 1954, R. W. B. Lewis extends Smith's thesis by examining the heroic figure central to the mythic wilderness quest. This "American Adam," as his name suggests, provides

not merely a historical and literary paradigm for the American experience, but a spiritual one. The "authentic American," Lewis writes, derives from the biblical Adam, "a figure of heroic innocence and vast potentialities, poised at the start of a new history" (1). The hero's quest in the wilderness too, then, is cast in spiritual terms. At Walden Pond, Thoreau seeks both physical solitude and the spiritual truths to be found in communion with nature. Whitman, similarly, celebrates not only the American landscape, but the souls and spirits of men. Huck Finn confronts not only physical freedom and adventure on the great river, but his own conscience and the hypocrisy of traditional religious practice. Nick Adams retreats to the wilderness seeking new meaning for his life in the aftermath of war. The American literary landscape is, from its beginnings to its present incarnation, a spiritualized one; and these writers, canonized as "most American," write of quests and adventures which are both physical and spiritual.

Despite the universality which its central position in American literature implies, a spiritual quest tradition which mandates solitary flight from family and community is a tradition which pointedly excludes women. As Nina Baym notes in her important essay, "Melodramas of Beset Manhood: How Theories of American Literature Exclude Women Authors," only men in American society have traditionally had the mobility required to undertake a "believable flight into the wilderness" (72). The myth not only precludes the possibility of women as questing heroes; it also casts women as the domestic conservators whom the heroic Adam must flee. Mythic heroes from Natty Bumppo to Nick Adams leave behind mothers and wives, sisters and lovers as they embark on solitary quests in search of spiritual truth. Thus excluded from quest, are women characters also excluded from the realm of spiritual experience? Or might texts by American women writers offer alternative patterns for spiritual seeking?

In her essay, Baym points out that the spiritual quest paradigm which dominates the American canon illuminates a central myth regarding the relationship of the individual to society:

> The myth narrates a confrontation of the American individual, the
> pure American self divorced from specific social circumstances,
> with the promise offered by the idea of America. The promise is

> the deeply romantic one that in this new land, untrammeled by
> history and social accident, a person will be able to achieve com-
> plete self-definition. Behind this promise is the assurance that indi-
> viduals come before society, that they exist in some meaningful
> sense prior to, and apart from, societies in which they happen to
> find themselves. The myth also holds that, as something artificial
> and secondary to human nature, society exerts an unmitigatedly
> destructive pressure on individuality. (71)

This myth, Baym suggests, has less to do with the quality of
"Americanness" than with "what is alleged to be the universal male psy-
che" (79). Indeed, the premise that self-definition is achieved through
separation and individuation has, until recently, been the unquestioned
center of modern psychological theory, from Sigmund Freud's theory
of the oedipal conflict to Lawrence Kohlberg's studies of the stages of
moral development.

Traditional psychological theories "tend to see all of development
as a process of separating oneself out from the matrix of others," writes
psychologist Jean Baker Miller. "Development of the self presumably
is attained via a series of painful crises by which the individual accom-
plishes a sequence of allegedly essential separations from others and
thereby achieves an inner sense of separated individuation"
("Development" 437). The fact that this notion of male separation and
autonomy is a myth does not diminish but rather strengthens its influ-
ence, Miller asserts:

> Few men ever attain such self-sufficiency, as every woman knows.
> They are usually supported by numbers of wives, mistresses,
> mothers, daughters, secretaries, nurses, and others. . . . Thus, there
> is reason to question whether this model accurately reflects men's
> lives. Its goals, however, are held out for all, and are seen as the
> preconditions for mental health. ("Development" 437)

This image of the mature, fully developed person as one who has suc-
cessfully separated and differentiated from others recalls Lewis's descrip-
tion of the mythic American Adam, "untouched and undefiled by the
usual inheritances of family and race; an individual standing alone, self-
reliant and self-propelling" (5). In the American literary canon, as in

the literature that has shaped our contemporary understanding of human psychology, maturation is linked to separation from the societal constraints embodied by women.

Feminist theorists in psychology, sociology, theology, and education have challenged these models of psychological and spiritual development, arguing that women's experience does not necessarily fit the paradigm they present. Research by Miller, Carol Gilligan, Nancy Chodorow, and others suggests that, while boys and men tend to define themselves largely through separation and differentiation, girls and women often define themselves largely through relationship. As both Miller and Gilligan point out, psychological development is as clearly shaped by attachment as it is by separation. Human beings define themselves in part in their relation to others from earliest infancy; yet, Gilligan writes, "This capacity is not well represented in accounts of human development, in part because it is at odds with the image of relationships embedded in the prevailing concept of the self" ("Remapping" 483). Because traditional psychological theories are based on a male model for human development, however, the psychological development of girls and women is seen as not merely different, but deficient. "The quality of embeddedness in social interaction and personal relationships that characterizes women's lives in contrast to men's . . . becomes not only a descriptive difference but also a developmental liability when the milestones of childhood and adolescent development in the psychological literature are markers of increasing separation," Gilligan writes. "Women's failure to separate then becomes by definition a failure to develop" (*Different Voice* 8–9).

Only in recent years have researchers begun to examine female psychology not as a failed version of the male model, but as a distinctive pattern of development. Women's sense of the self as defined, in part, by relation to others leads to a form of "contextual thinking" among women that emerges in a variety of situations. In her studies of women's moral decision-making, for example, Gilligan judges women's moral development not in relation to a male model, but in the light of Chodorow's observation that, "in any given society, feminine personality comes to define itself in relation and connection to other people

more than masculine personality does" ("Family Structure" 43–44). As a result, Gilligan found, women reject the code of absolute moral standards by which psychological maturation has traditionally been judged in favor of their "own experience of the complexity of moral choice" and its contextual nature (*Different Voice* 55). Similarly, educator Mary Belenky finds that women in the classroom tend to learn in ways that are collaborative and cooperative rather than individualistic and competitive. Noting that, in Western culture, "attributes traditionally associated with the masculine are valued, studied, and articulated, while those associated with the feminine tend to be ignored," Belenky observes that "we have learned a great deal about the development of autonomy and independence, abstract critical thought, and the unfolding of a morality of rights and justice in both men and women. We have learned less about the development of interdependence, intimacy, nurturance, and contextual thought" (Belenky et al. 6–7).

Philosopher Sara Ruddick has also studied this kind of "connected knowing," which is linked to relationships and to real life rather than hypothetical situations, and has named it "maternal thinking." As mothers, Ruddick writes, women may "reject the demands of abstraction and instead look closely, invent options, refuse closure. . . . This way of knowing requires a patient, sympathetic listening to the complexities and uncertainties of another's experience quite unlike the acceptance of the given terms required for abstraction" (95–96). What links these researchers in disparate fields is their assumption that, because they are socialized differently, women and men develop different strengths, weaknesses, and perceptions of the world. When viewed in this light, studies of women's learning patterns or theological perceptions reveal not inferior versions of male developmental models, but patterns based on women's distinctive life experiences.

These studies have been the subject of intense critical debate, both in academic works and in popular press post-feminist critiques such as Carol Tavris's *The Mismeasure of Woman* (1992) and Naomi Wolf's *Fire with Fire* (1993). Few of these critics deny that most women both *experience* and *describe* their lives as being organized around relationships in a way that most men do not. The point of disagreement most often lies

in whether women's and men's experiences, and their differing perceptions of these experiences, suggest fundamental differences in nature or psychological makeup. Are gender differences rooted in early child rearing, as psychoanalytic critic Nancy Chodorow suggests? Do they develop in the self-censoring behavior of adolescent girls who, Lyn Mikel Brown and Carol Gilligan theorize, learn to repress their own strong voices in order to meet social expectations as they emerge into womanhood? Whether woman's "difference" is a strength or a liability, a weakness or a model for change, and whether its origins are biological, psychological, or cultural remains a subject of critical debate.

Although Carol Gilligan's research has entered popular discourse as a finding of essential differences, however, Gilligan herself describes "the central assumption of [her] research" as the assertion "that the way people *talk* about their lives is of significance, that the language they use and the connections they make reveal the world they see and in which they act" (*Different Voice* 2; emphasis mine). My interest in the connection between fiction and theories such as Gilligan's lies in the observation that fiction is one way that women "talk" about their lives. Indeed, Jean Baker Miller views art as an arena in which alternative models of human development are frequently expressed: "We have all been laboring under only one implicit model of the nature of human nature and of human development. Much richer models are possible. Glimpses of them have always been struggling to emerge, through the artists and the poets, and in some of the hopes and dreams of us all" ("Development" 453). Because women's traditional sphere of activity has been marginalized rather than being acknowledged as an integral part of our culture and a source of our knowledge and values, Miller continues, domestic and caretaking activities are often idealized in our culture, sounding "almost unreal" when described as the basis of many women's life experience ("Development" 452). Thus, the same culture which views "Hemingway's endless details about how to bait a fishhook" as the stuff of high art, Kathryn Rabuzzi points out in *The Sacred and the Feminine,* has commonly dismissed novels detailing women's domestic lives as trivial, sentimental, and subliterary.

Traditional Western theology, like psychology, has been shaped

primarily by male experience. Spiritual quest constructed as a flight from domestic and communal life is a paradigm which pervades Western theology as well as Western literature. "The idea of a spiritual journey is endemic to spiritual writing," Carol Ochs writes in *Women and Spirituality:*

> The image of the journey permeates the classics of Western spirituality. The notion of a journey with a well-marked itinerary permeates psychology as well . . . both presuppose a linear progression with later stages that are valued more highly than earlier ones. . . . The adoption of the journey model carries with it the view that part of our life has meaning and value only insofar as it contributes to the goal of the journey. Living in itself is not considered intrinsically valuable—the only value is in the goal we supposedly long to achieve. (23–24)

Thus elevated to archetypal status, the spiritual journey has emerged not merely as one construction of spiritual experience, but as a universal spiritual truth. "Throughout recorded time men have 'named the sacred,' from the standing point of the male body and male life experience," Elizabeth Dodson Gray writes in *Sacred Dimensions of Women's Experience.* "Men . . . take private, personal ideas coming out of the particularity and specificity of their own lives and experiences . . . and they make those private, personal reflections into universal truths" (1).

Just as the canonical literature has depicted a distinctly male psychological phenomenon as universally "American," so has Western theology portrayed a male-centered world view as universal spiritual experience. The emphasis on quest in patriarchal theology has resulted in a "landscape of the sacred" in which, Gray writes, only "[a] few places, a few people, a few occasions are seen to concentrate and to embody the holy. . . . The only moments in time which become hallowed by an aura of holiness are those which involve these places, these people, these texts and these acts. The rest of life is perceived as a vast desert of the mundane, the *unholy*" (2). In *Women and Spirituality,* Ochs concurs: "Definitions of traditional spirituality grow out of the view that spirituality is the highest state of maturity. When maturity is seen in terms of a male developmental model, our highest task is to achieve individuation. This requires separation of the self from its supporting environment" (10).

While Western theology tends to view sacred experience as separate from ordinary, earthly experience, feminist theology emphasizes the presence of the sacred embodied in earthly experience and questions the Western theological tradition of the hierarchical chain of being. Feminist theology views personal experience not as trivial or mundane, but as an authoritative source of spiritual revelation. Unlike patriarchal theology, which establishes a few places and activities as realms of the sacred, feminist theology locates the sacred in ordinary experience. "The spiritual life is not forced, contorted, agonized, or rare," Ochs writes; "it is ordinary, readily available, and it surrounds us all" (14). Gray agrees, locating the source of spiritual experience in the dailiness of women's lives: "Instead of distancing ourselves and withdrawing from the reality of life to find sacredness, we go toward that reality—toward bodies, toward nature, toward food, toward dust, toward transitory moments in relationships" (2).

In recent years, feminist theologians have sought to identify ways in which women's lives shape their perceptions and definitions of spiritual experience. The root of theology, feminist theologian Rosemary Ruether writes in *Sexism and God-Talk,* is "codified collective human experience. . . . 'Experience' includes experience of the divine, experience of oneself, and experience of the community and the world, in an interacting dialectic. Received symbols, formulas, and laws are either authenticated or not through their ability to illuminate and interpret experience" (12). Western theological tradition, however, has dismissed those who create their own religious myths as heretics. "Human beings of different sexes, ages, races, and environments have different experiences of spirituality and religious phenomena," Naomi Goldenberg writes in *Changing of the Gods.* "Theologians are ignorant of what every anthropologist knows—i.e., that the forms of our thought derive from the forms of our culture" (115).

Feminist theologians are thus distinctive in acknowledging what Ruether terms "codified, collective human experience" as an authoritative source of spiritual truth. The fact that the kinds of experiences that have been "collected" and "codified" in Western culture have been almost exclusively male, however, has resulted in a male-centered theology. "The uniqueness of feminist theology lies not in its use of the

criterion of experience but rather in its use of *women's* experience, which has been almost entirely shut out of theological reflection in the past," Ruether writes. "The use of women's experience in feminist theology, therefore, explodes as a critical force, exposing classical theology, including its codified traditions, as based on *male* experience rather than on universal human experience. Feminist theology makes the sociology of theological knowledge visible, no longer hidden behind mystifications of objectified divine and universal authority" (13). If women's daily lives are radically different from those of men, then their understanding of divinity will be shaped by those experiences, emerging as a distinctively female spirituality.

Just as few women view the quest motif—with its emphasis on individual achievement, the wilderness journey, and separation from community—as a pattern for their lives, few American women writers adopt this motif as a paradigm for spiritual seeking. Nonetheless, spirituality forms a central theme in the fiction of many twentieth-century American women writers. In this study, I define spirituality as positive transformative experience. This definition derives from what theologian Richard Grigg terms enactment theology, an idea shared by many feminist theologians, in which the divine exists not "as a reality independent of human sensibilities and projects," but "as a reality that is actualized through those sensibilities and projects" (55). In enactment theology, Grigg explains, "the divine is a relation that human beings decide to enact" (55). This relation may be with either an immanent or a transcendent other—other people, nature, the power of being, or some other entity. This relationship is both real and, in Grigg's terms, "something more than the sum of its constituent elements. Indeed, this relation is the divine . . ." (53). Enactment theology thus displaces the traditional theistic notion of God "as a supernatural personal agent, a transcendent consciousness who acts independently of human perceptions and projects," Grigg writes (29). Rather than reducing divinity to a mere psychological projection, however, enactment theology allows the believer to "[reclaim] the whole of human experience and activity as the domain of divine influence" (47). In my definition, what is *enacted* in the literary texts examined here is a positive transformation, most

often taking the form of gaining wisdom, healing from spiritual bro-
kenness, learning moral lessons, or other forms of positive change.

Because the life experiences of women and men are so often dif-
ferent, different activities enact the spiritual in women's and men's texts.
In the canonical quest story, for example, the male protagonist's physi-
cal journey into the wilderness enacts the spiritual journey. The jour-
ney is not in itself spiritual, but is spiritualized when it effects positive
transformation in the protagonist. In this study, I will examine three
areas of female experience which serve in American women's writing
as realms of the spiritual: domesticity, community, and storytelling.
Each of these experiences, like the quest, reflects a theology of enact-
ment: rather than connecting the seeker with an external, independent,
transcendent God, the experiences of domestic practice, participation
in community, and storytelling *create* sacredness by effecting positive
transformation. Domesticity, community, and storytelling thus serve
the same spiritual function as the quest, but with women's life experi-
ences as their source.

My point in this study is not to suggest that these three paradigms
for women's spiritual experience are either definitive or exhaustive. In
my own reading of American women writers' texts, I have been struck
by particular patterns of transformation: by these writers' reclamation
of the domestic sphere—the most ordinary and even oppressive dimen-
sion of women's lives—as a realm of comfort, healing, and meaning;
by their depictions of community as a potentially transformative source
of wisdom and love; by the frequency with which the characters in
these texts repudiate the scripts of conventional religion, substituting
the stories of their own lives as sources of truth; in short, by the way
that mysterious and ineffable transformations are effected in women's
texts, not through solitary wilderness journeys, but through ordinary,
daily activities and interactions. Other readers will surely locate spir-
ituality in other aspects of women writers' texts. My aim here is simply
to suggest that, when women's experience of spirituality becomes the
subject of study, the quest model is thrown into question and a myriad
of alternative paradigms become possible.

Domesticity represents an almost exclusively female domain and

is practiced by virtually all women to a greater or lesser extent, crossing barriers of race, economic class, and historic period. In the canonical literature, domestic spaces and activities have traditionally been treated as the marginal or invisible backdrop for "significant" action—carried out, of course, by men, in the male-dominated public realm. As recent works such as Ann Romines' *The Home Plot* and Helen Fiddyment Levy's *Fiction of the Home Place* demonstrate, however, many women writers place domestic activities at the center of their texts, thus allowing a new exploration of their meaning and significance. Expanding on Romines' and Levy's studies, I will examine literary constructs of domesticity as enactments of the spiritual.

Ann Romines has called Sarah Orne Jewett's *The Country of the Pointed Firs* "the American ur-text of domestic ritual" (48). Indeed, few works in American literature so eloquently celebrate the rhythms, symbols, and practices of domesticity as Jewett's evocative and lyrical stories. In many ways, however, Jewett also suggests that domestic practice is transformative. In Jewett's fictional world, domestic rituals do not merely provide comfort, but also preserve life, relationships, and community. Domestic activities such as gardening, visiting, and preparing meals thus take on the import of sacred rites. Further, Jewett frequently depicts domestic ritual as a link between the living and the dead, thus blurring the distinction between earthly and spiritual life and suggesting that the domestic and spiritual worlds have fluid, overlapping boundaries. Her Dunnet Landing women are both ordinary and transcendent, grounded in the everyday world of domestic activity, yet also transformed through those activities. While female characters create and preserve this domestic space, Jewett nonetheless portrays it as an ideal realm for both women and men, favorably contrasting the domestic sphere with the quest-driven lives of most of her male characters.

In *The Bluest Eye,* Toni Morrison, like Jewett, both places domestic life at the center of her text and suggests that domestic ritual has transformative power. Morrison's domestic world, like Jewett's, is mythic and mysterious, connected with the rhythms of the seasons and with the power to sustain and preserve life. While Jewett offers a romanticized and idyllic portrait of domestic life, however, Morrison depicts the dark potential of a home life devoid of sustaining domestic

practice. Morrison juxtaposes the MacTeer family's poor but loving home, which offers protection from a harsh external world, with the violence and dissolution in the Breedlove household. Morrison thus privileges domestic life without idealizing it, showing that even home is not invulnerable to the threats of racism, hatred, and violence. As in Jewett's text, here domestic space is created and preserved by women, yet is essential to the lives of both women and men. Within this fictional world, the threat of being cast "outdoors" rules the lives of all of Morrison's characters. "Outdoors" in Morrison's text is not merely a physical state, but also a psychic one, suggesting a complete absence of belonging. Home, by contrast, has the potential to protect and sustain life, both physically and emotionally, in a violent world.

In Kaye Gibbons' *Ellen Foster,* as in *The Bluest Eye,* homelessness is both a physical and a psychic state. Gibbons, like Morrison, holds up home as an ideal which offers both physical protection and a sense of meaning and belonging, yet she also recognizes the abuses possible within a violent household. Ellen, like Pecola Breedlove, is threatened by her father's alcoholism and sexual abusiveness and is forced to flee her home. Her journey, however, unlike the canonical quest, is not a linear flight *from* home, but a circular journey *to* home. In fleeing her own abusive household, Ellen seeks a true home that will offer both physical protection and a sense of meaning and belonging. While, for the canonical American hero, the flight from home signifies freedom— Huck Finn, who also flees an abusive father, finds perfect contentment adrift on a raft—for Ellen, homelessness signifies chaos and meaninglessness. Her quest is thus both a literal search for physical shelter and a spiritual quest. Gibbons, like each of the writers discussed here, constructs home not as inherently sacred, but as a potentially sacred space. Domestic practice enacts the spiritual when it offers respite from the dangers of the temporal world and healing from emotional wounds.

While the male spiritual quest is traditionally a solitary one, women's spiritual experience is most often grounded in community. As studies such as Nina Auerbach's *Communities of Women,* Lillian Faderman's *Surpassing the Love of Men,* and Sandra Zagarell's "Narrative of Community: The Identification of a Genre" illustrate, female community often forms the focus of narrative strategy in women's texts.

Rather than serving as a barrier to spiritual quest, as in the canonical male quest story, in these texts community often serves as the source of transformation which is the fulfillment of spiritual quest; conversely, isolation, rather than community, is constructed as a threat to such transformation. The female characters depicted in these texts experience spirituality not in solitary flight, but in supportive communities.

In Jewett's *The Country of the Pointed Firs,* gradual integration into the community shapes the narrator/visitor's summer at Dunnet Landing and her increasingly sympathetic response to its residents. The narrator initially perceives her quest as a solitary one; she has sought out Dunnet Landing, expressly because of its solitude, as the ideal place to accomplish some writing. Gradually, however, the narrator finds that her hard-won solitude cuts her off from the true source of inspiration, which is to be found in community. As she receives Mrs. Todd's training in such domestic practices as herbal medicine and visiting, the narrator finds that the importance of these tasks lies in the link they form among members of the community. Her intended linear journey from community to solitude is replaced by a series of circular journeys—visits which strengthen ties among community members, then culminate in the return journey home. Jewett casts these visits as sacred rituals that transform both the visitor and the community itself as wisdom is exchanged, loneliness abated, and rifts healed. Thus, the narrator rejects the solitary quest in favor of the rich communal life to be found among the inhabitants of Dunnet Landing.

Although she does depict loneliness and isolation as threats to community, Jewett's vision of community is largely an idyllic one. By contrast, Harriette Arnow's *The Dollmaker* reflects both the transforming power of community and its vulnerability to divisive forces: war, industrialism, poverty, ethnic tensions. Arnow's Gertie Nevels, like Jewett's narrator, initially seeks artistic vision in solitude, seeking moments alone to work on her perpetually unfinished wood sculpture of Christ. In the housing projects of Detroit, Gertie initially finds this war-ravaged community to be only a hindrance to her own transformation as an artist. When a tragedy forces the women of the community to confront their commonalities, however, this female community ultimately transcends prejudice and hatred, and Gertie finds the face of

Christ she has been seeking: not in solitude, but in the faces of her neighbors. As in Jewett's text, in *The Dollmaker* community brings transformation by healing various ills of the spirit: isolation, prejudice, hatred. Spirituality is found not in the solitary flight from community, but in integration into community.

In *The Color Purple,* Alice Walker, like Arnow, depicts lives threatened by prejudice, hatred, and violence. Within this harsh environment, however, community effects transformation. Walker's female characters create alliances that overcome the barriers which threaten to separate them from one another. Within this community, Walker's protagonist, Celie, also finds a vision of God to replace the religious tradition that has oppressed her. Celie's new vision of God challenges traditional notions of hierarchy within creation, emphasizing instead the interdependence of all life. It is this "Creation" into which Celie enters in Walker's text, rejecting her isolated and repressive life for a life strengthened by an alternative family comprised of friends, former enemies, and lovers.

In *Beloved,* Toni Morrison depicts both the saving power of community and the horrific consequences when the community fails in its role of protecting and caring for its members. Morrison casts Baby Suggs's role in sustaining community as a calling, a ministry which rejects the authority of conventional religion. When this community becomes jealous and angry, however, it fails to protect Baby Suggs and her family. Sethe's murder of her infant daughter takes place, in part, because the community, nurturing its own jealousy and anger toward her, fails to warn her of approaching slave catchers. In the ensuing years, Sethe's pride and the community's judgment result in an isolation which makes Sethe and her surviving daughter vulnerable to the baby's vengeful spirit. Sethe's family is saved from the evil threatening it only when the neighboring women, abandoning their prejudices, march into the yard at 124 Bluestone Road to drive it out. Thus, as in both Arnow's and Walker's texts, Morrison depicts the dark potential of community to repress and destroy as well as its potential to transform. Community is, therefore, not inherently spiritual; rather, it becomes spiritual when it functions to effect positive transformation in its members.

A final area of spiritual experience I will examine is that of storytelling. In canonical male stories, female characters have traditionally been

peripheral, their presence either invisible, marginal, or even threatening: Frederick Douglass's fiancee Anna, who appears only in the final pages of his narrative; Huckleberry Finn's Widow Douglass, whose mission to "sivilize" him threatens his quest; Nick Adams's empty relationships with women, abandoned as he seeks new meaning for his life in "Big Two-Hearted River." In many women writers' texts, however, female characters serve as the speaking subjects of their own life stories. In the texts discussed here, storytelling is transformative for both the female characters who tell the truth about their lives and the hearers who make the storytelling possible through their sympathetic listening. Often, these stories function as parables to guide younger women, conveying moral lessons and transcending barriers of physical distance, age, and race. Their stories, grounded in the experiences of women's lives, thus serve as a form of truth-telling that provides alternatives to the dominant male story of spiritual quest.

In many of Sarah Orne Jewett's short stories, storytelling effects healing transformation for women who are separated from one another by physical distances, time, and even death. Through her stories, Mrs. Todd guides and teaches her younger friend about community, thus imparting lessons while also forging a more intimate connection between the teller and the listener. In Jewett's ghost stories, storytelling serves as a form of conjuring, with her storytellers summoning the spirits of the dead to offer wisdom, guidance, and comfort. Nonetheless, Jewett revises traditional notions of the ghost story by casting these spirits not as frightening apparitions, but as comforting reassurances of connection and life which extend beyond the physical world. By providing connection even to those loved ones who have died, and thereby assuaging fears of death, storytelling functions to transform both individuals and communities.

In Zora Neale Hurston's *Their Eyes Were Watching God,* storytelling effects transformation by allowing the formerly passive and silent female protagonist to tell the truth about her life. As she learns to speak for herself, Janie rejects several "authoritative texts" about her life: those offered by her grandmother, her first two husbands, and the Eatonville community. Hurston describes Janie's new self-realization as a "resurrection," thus characterizing this transformation as sacred. While Hurston's text is clearly influenced by the pattern of the quest story,

she revises this pattern in two important ways. Janie's quest is not linear, but circular; she ends her journey by returning, with the benefit of all of her experiences, to the community she had fled. The frame narrative also revises the pattern of the quest story by linking Janie to the community. Her spiritual journey culminates when she is able to tell her own, authentic story to a sympathetic listener who will, oracle-like, tell that story to the rest of the community. Storytelling thus transforms both teller and listener and forges connections within the community.

Katherine Anne Porter's Miranda stories reflect both the transformative potential of storytelling and its inherent dangers. In Porter's stories, as in Jewett's, storytelling serves to break down barriers that separate her characters. In "The Old Order," Miranda's grandmother and her black servant, Nannie, use storytelling to knit together a friendship threatened by the divisions of race and social class. In "Old Mortality," similarly, storytelling provides access to the past, to long-dead relatives and the wisdom to be gained from their lives. However, Porter also illustrates the potential of stories to paralyze by distorting the past, either through idealization or through bitterness. While the transformative power of storytelling lies in its potential to preserve the past for future generations, to live in the present is neither to dwell on the past nor to forget it, but to manage a subtle negotiation of lessons from the past with present-day realities.

If the quest appears an inappropriate literary motif for women writers and female characters alike, the wilderness into which the Adamic hero flees seems equally inaccessible. In many male writers' texts in the American canon, the wilderness suggests a world far from constraining civilization. Here the male protagonist is free to explore his own essential, untamed nature as well as the mysteries of the spiritual world. In the quest stories of nineteenth-century literature—Cooper's *Leather-Stocking Tales,* Melville's *Moby Dick,* Twain's *Adventures of Huckleberry Finn*—this wilderness is the quite literal one of unexplored American frontiers. Beginning with modernist works and throughout twentieth-century literature—Eliot's "The Waste Land," Ellison's *Invisible Man,* Hemingway's *The Old Man and the Sea*—the wilderness is a more highly symbolic one which nonetheless suggests that wisdom is to be found in the flight from home and community.

In many women writers' texts, by contrast, if a "wilderness" appears at all, it is most often constructed as a chaotic and threatening environment. While nature does appear as a metaphor for the spiritual realm in women writers' texts, it is more often as a garden or other domesticated outdoor space. Mediating between untamed nature and the domestic realm, the metaphorical garden serves as an extension of both, thus suggesting the fluidity of boundaries between the temporal and spiritual worlds. Further, the substitution of the garden for the wilderness reinforces the idea that the spiritual may be located in quite ordinary spaces of everyday lives, rather than on the horizon.

In Jewett's *The Country of the Pointed Firs*, Mrs. Todd's herb garden clearly represents such a mediating space between the earthly and the spiritual. Jewett constructs Mrs. Todd's healing power as something both mystical and ordinary, associated with the spiritual world and with healing powers, yet rooted in the humble plants found in a kitchen garden. The home of Mrs. Blackett, Jewett's consummate mother figure, is also a place where the lines between nature and home are blurred. Here domestic practice is intensely dependent on nature's gifts; dinner relies upon a good day of fishing and the flourishing of vegetables from the garden. In Mrs. Blackett's home, as elsewhere in Jewett's text, the preparation of meals and other domestic tasks serve as sacred rites which sustain and nurture life. The goal of these characters in seeking the spiritual seems not to be an escape from the domesticated realm into the spiritual realm of the wilderness, but a combining of the two.

Willa Cather's *O Pioneers!* similarly provides an alternative to the quest for spiritual truth in the untamed wilderness. Alexandra's farm is more garden than wilderness, a domesticated space that mediates between the spiritual essence of the land and the values associated with home. Cather casts John Bergson's failure as a farmer as a failure of spirit; she personifies the recalcitrant prairie, citing its "unfriendliness" to the pioneers who try to conquer it by force. Cather portrays Alexandra's triumph, similarly, in spiritual terms. In developing a sympathetic understanding for the "Genius of the Divide," Alexandra is able to nurture its gifts rather than break its spirit.

Like Cather's Alexandra Bergson, Harriette Arnow's Gertie

Nevels shares a relationship with nature based on sympathy and under-
standing rather than on conquering. In Arnow's *The Dollmaker,* nature
clearly serves as a metaphor for the spiritual world and as a substitute
for traditional religion; Gertie Nevels rejects the religious tradition of
her family and community, instead finding nearness to God in nature.
As in Jewett's and Cather's texts, however, Arnow locates spiritual truth
not in an untamed wilderness, but in a cultivated outdoor space. For
Gertie Nevels, farming is a sacred occupation, providing both nearness
to the land and food for her family. When her move to a harsh urban
environment cuts her off from contact with the land and from the abil-
ity to provide for her children, her religious vision is lost.

In Toni Morrison's *The Bluest Eye,* gardens represent both the
potential and the limitations of the human spirit. Like the gardens that
they plant, Morrison's characters require a nurturing environment in
order to thrive. The familial care provided to Claudia and Frieda
MacTeer, even in a harsh urban environment, ensures their healthy
physical and spiritual growth. The life of their friend Pecola, however,
who is deprived of a loving and nurturing home, is linked with
marigold seeds that refuse to grow. Gardening in Morrison's text, as in
Jewett's, is associated with conjuring—the ability to call forth spiritual
forces. Morrison, however, illustrates the limitations of conjure when
Claudia and Frieda's planting of seeds fails to save Pecola. The "ground"
of which Pecola's home life is made will not nurture either seeds or a
child, and supernatural intervention alone is not powerful enough to
save her. Spirituality is not separate from earthly life, but is enacted
through nurturing relationships in this life.

In Gloria Naylor's *Mama Day,* intimacy with the natural world is
closely linked with the possession of supernatural powers. The rela-
tionship between the human world and the spiritual world is a sympa-
thetic one in Naylor's text, and nature often mediates between the two,
offering signs to the living about how to exist in harmony with the spir-
its. Miranda Day is both conjure woman and gardener, using the
resources of forest and garden to heal both physical and emotional ills.
The physical and spiritual needs of the community are thus intertwined,
both provided for by the natural world. Further, Naylor's "wilderness"

provides not escape from family and community, but further connection to them; the family homestead is clearly defined as a sacred space where the living and the dead coexist.

The female protagonists of these texts, like their male counterparts, seek transformation. Traditionally, the source of such transformation in the male spiritual quest myth is found in the solitary journey to the wilderness: "In [the] old spiritual game, it is clear that the movement of holiness is up, the direction is away, and the motivation is to escape from 'here' to 'there,'" Elizabeth Dodson Gray writes (2). Women's experience of the spiritual as expressed in these literary texts, however, is different. Spirituality in the works of these women writers is most often found in community, rather than in solitude. It is egalitarian and non-hierarchical, locating the divine in the humblest of ordinary pursuits. The characters in these works experience a fluidity between the spiritual and temporal worlds which deconstructs conventional dualisms between spirit and body, heaven and earth, God and human. They experience the divine through connection, by looking to home and community, and to the personal stories women tell about their lives.

Although my focus in this study is on twentieth-century writers, I believe that Sarah Orne Jewett's tales provide an important link to nineteenth-century American women writers who also treat spiritual concerns, although frequently within a model provided by male-centered religious traditions. Jewett's deeply spiritual texts also provide a model for the female-centered spiritualities found in many twentieth-century women writers' texts. Later incarnations of Jewett's house-keepers, herb gatherers, storytellers, and other wise women are found not only among the works discussed in this study, but in the fiction of many other twentieth-century women writers.

In examining this diverse group of writers, I am aware of the pitfalls that reference to "women's experience" poses, particularly when writing of the experiences of both African-American and white women. Critics in many disciplines have argued, quite rightly, that feminist scholars have obliterated important distinctions *between* women in their eagerness to find commonality *among* women. Women's experience is clearly not homogeneous, either in literature or in life; it represents a rich plurality that is molded by race, ethnicity, socioeconomic level, edu-

cational background, age, marital status, sexual orientation, and count-less other important considerations. I believe that it is possible, however, to seek similarities in women's experiences *as women* without discount-ing these differences. To disallow discussion of "women's experience" privileges cultures created by shared race while discounting the culture of gender. My reading of these diverse texts is, to borrow a theological term, "synoptic": "a reading together of thematically similar sources in search of a common story" (Morey 7). In these texts, women's experi-ences of domesticity, community, and storytelling as realms of the sacred form a part of that "common story."

Chapter II

Home as
Sacred Space

Some keep the Sabbath going to Church—
I keep it, staying at Home—
 —Emily Dickinson

Recent studies such as Ann Romines' *The Home Plot* and Helen
Fiddyment Levy's *Fiction of the Home Place* have identified "domestic fic-
tion" as an important literary form during both the nineteenth and twen-
tieth centuries. While the influence of domestic life on some of these
texts is clear—most notably nineteenth-century "sentimental fiction"—
Romines notes that other, less obviously domestic texts are "dominated
and shaped by the rhythms and stresses of domestic ritual, by the com-
plex of domestic-literary concerns . . . called the home plot" (9). As both
Romines and Levy point out, domestic themes have so long served as
the invisible backdrop for "important" action in American literature that
they may not be readily identifiable to the reader unaccustomed to the
language and rhythms of literary domesticity. Nonetheless, these critics
argue that domestic themes are central to texts by not only Harriet
Beecher Stowe, Sarah Orne Jewett, and Mary Wilkins Freeman, but
such twentieth-century writers as Willa Cather, Ellen Glasgow, Eudora
Welty, Katherine Anne Porter, and many others.

 Domestic work, in literature as in life, is a paradox: it carries little
prestige, is low-paid or unpaid, and is, by its very nature, undone nearly
as quickly as it is completed; yet it is also the work without which, as

Virginia Woolf notes in *A Room of One's Own,* "those seas would be unsailed and those fertile lands a desert" (112). Housekeeping is, in Romines' terms, a "sacramental activity" which perpetuates both the physical and the spiritual well-being of a household. Domestic activity may thus function as a form of enactment, its meaning lying not in the tasks themselves, but in the relationship that domestic ritual establishes among the housekeeper and other household members. When it functions to preserve and sustain life, domestic ritual enacts the sacred.

As scholars in a number of disciplines have noted, domestic practice also challenges traditional conceptions of time as linear. "Though we know better," theologian Kathryn Allen Rabuzzi writes in *The Sacred and the Feminine,* "we often act as though linear, quantifiable time (associated with questing) were given in nature. . . . This kind of time that we assume is 'out there' we describe as historic, meaning that it is progressive and nonrepeatable, having a forward motion like the flow of a river. Individuals living in the modern Western world grow up so imbued with this time pattern that it seems given in nature" (145). This conception of time both derives from and describes lives driven by quest—the linear journey through a series of incidents or episodes and directed toward a goal. Within this framework, the circular, repetitive, and non-goal-oriented nature of domestic work has unavoidably negative connotations. "[W]ithin Western patterns of conceptualization, stasis . . . implies lack of progress, absence of motion, and even death," Rabuzzi writes. "Entrapment by a woman—a pervasive theme in numerous variations throughout literature—is life in a time frame so at variance with the quest mode that it feels like living death by contrast" (146–47).

As Rabuzzi points out, however, domestic activity has very different associations when viewed within the context of mythic time. Mythic time, as described by theologian Mircea Eliade, is not linear but circular, "reversible and recoverable, a sort of eternal mythical present that is periodically reintegrated by means of rites" (70). Within traditional religious practice, festivals and holy days usually represent the presence of the mythic in the midst of ordinary, or historic, time. As Romines points out, however, "for many traditional women, who have invested much of their selfhood in housekeeping, ritual is domestic, and it is a constant of everyday life. Their ritualized housekeeping may be

a sacramental activity that provides essential cultural continuity. . . . What these women do is essential yet impermanent and invisible . . ." (6). Suggesting that domestic tasks may function as sacred rites, Rabuzzi points out that domestic life is "typically characterized by amorphousness or circularity or both" (146). In *Tapestries of Life,* Bettina Aptheker describes women's lives as "fragmented and dispersed," "episodic," "they are often determined by events outside of women's control. . . . Women are continually interrupted" (39). In *The Reproduction of Mothering,* sociologist Nancy Chodorow concurs, writing that women's domestic activities have a "nonbounded quality. They consist, as countless housewives can attest and as women poets, novelists, and feminist theorists have described, of diffuse obligations. . . . the work of maintenance and reproduction is characterized by its repetitive and routine continuity, and does not involve a specified sequence of progression" (179). Many domestic novels thus link domesticity and spirituality in two ways: by depicting domestic activity as the enactment of transformative, life-sustaining relationships, and by suggesting a connection between the cyclical nature of domestic work and the amorphous, subjective character of mythic time.

In the mid-nineteenth century, writers of sentimental local color fiction became the first American authors to place the domestic sphere at the center of their texts. These writers reflected changes taking place in the American economy and their effect on individual households. As historians Ann Douglas, Barbara Epstein, and others point out, productive work in the nineteenth century was increasingly the domain of men and was located largely outside the household, in the public realm, while the home became a more exclusively female sphere. With diminishing responsibility for producing household goods, women became increasingly occupied with the tasks of nurturing husbands and children physically, emotionally, and spiritually. Sentimental novelists of the period reflected this shift, placing female culture at the center of their tales of domestic life and emphasizing the central role of evangelical religion in the home. Many writers of sentimental fiction wielded conventional Christian piety as a powerful weapon, depicting their female characters as flawless, suffering heroines who triumph over debased male characters through goodness and passivity.

Although Sarah Orne Jewett is sometimes grouped with these writers of domestic fiction, her treatment of domestic and spiritual life in *The Country of the Pointed Firs* demonstrates a subtle but important shift away from traditional domestic themes and, in particular, traditional religion. Indeed, the female spirituality which permeates *The Country of the Pointed Firs* suggests stronger parallels with fiction by many twentieth-century women writers than with the work of Jewett's contemporaries. In *Pointed Firs,* domesticity serves not merely as the location of conventional religious practice, but as a religion in itself. Conventional Christian piety is exposed as empty and duplicitous, while domestic life and the mutual care provided within a female community yield a rich spiritual tradition. This profoundly female spirituality rejects the patriarchal hierarchies of the conventional church, celebrating "wise women" rather than male priests and mutuality rather than power. The spiritual truths to be found within this matriarchal religion are located in earthly life: in nature, in familial and community relationships, and in everyday domestic labors. As Ann Romines writes, "In lives as circumscribed as those of the residents of Dunnet Landing, validity and meaning are found not by striking out, but by going in deeper" (74). Religion in Dunnet Landing is not a religion of the journey, but a religion of the hearth.

Activity in Jewett's Dunnet Landing consists almost entirely of domestic ritual: housekeeping, visiting, tending the sick and troubled, gardening. Indeed, the most consistent complaint about her fiction by Jewett's critics is her lack of plot development; Jewett herself claimed that she had "no dramatic talent," and one early reviewer lamented, "It is, indeed, because [her stories] are so fine that one looks for something more important to happen in them than the eating of apples or the making of pie" ("Miss Jewett's 'A Marsh Island'" 64). In Jewett's world, however, the centrality of these seemingly "mundane" activities is precisely the point. Before the advent of local color literature, domestic work—preparing meals, tending children, cleaning the house—was invisible in literary texts or served as dim background activity for central, "important" action. In Dunnet Landing's matriarchal world, however, entire days center around the making of a visit or the preparation of a family feast. The import of these activities lies in both their life-

sustaining function—meals, after all, must be prepared—and their role in sustaining community among the women of Dunnet Landing.

In Jewett's fictional world, routine domestic tasks often take on extraordinary dimensions, enabling her characters with mystical powers and connecting them to a spiritual realm. Mrs. Todd is an herbalist by profession; she scours the Maine coast for healing plants and flowers and dispenses treatments from her kitchen door. Although the ingredients for her healing potions are common herbs, their effect is transcendent, even magical. Mrs. Todd's healing practice is not limited to physical ailments: she also treats "love and hate and jealousy and adverse winds at sea" (4). Jewett's narrator, "sophisticated" with urban knowledge, claims to be suspicious of both the physical and spiritual healing properties of Mrs. Todd's herbs; yet the language she uses to describe this domestic conjurer suggests otherwise:

> Some of these [remedies] might once have belonged to sacred and mystic rites, and have had some occult knowledge handed with them down the centuries; but now they pertained only to humble compounds brewed at intervals with molasses or vinegar or spirits in a small caldron on Mrs. Todd's kitchen stove. They were dispensed to suffering neighbors, who usually came at night as if by stealth, bringing their own ancient-looking vials to be filled. (4)

Although the narrator claims that Mrs. Todd's remedies represent nothing more than "humble compounds," her use of the term "caldron" to describe her friend's cooking pot and her description of neighbors arriving "at night as if by stealth," bearing "ancient-looking vials," suggests an incipient belief in the ancient powers being practiced at Mrs. Todd's kitchen door. Regarding some of her herbal medicines, Mrs. Todd maintains a mysterious silence; she will not discuss the use of "a simple which grew in a certain slug-haunted corner of the garden . . . I saw her cutting the tops by moonlight once, as if it were a charm, and not a medicine" (14). Thus, Jewett privileges the common domestic rituals of gardening and cooking both by placing them at the center of her text and by suggesting their power to effect both physical and spiritual healing.

Domestic spaces, as well as domestic activities, serve in Jewett's text

to blur distinctions between the physical and spiritual worlds. Mrs. Todd's garden produces not only humble herbs, but "some strange and pungent odors that roused a dim sense and remembrance of something in the forgotten past" (3–4). Mrs. Blackett's home on Green Island is a mystical space where the passing of years is halted. When the narrator visits the elderly woman, she finds that Mrs. Blackett "[takes] on a sudden look of youth": "you felt as if she promised a great future, and was beginning, not ending, her summers and their happy toils" (40). Reunited with her mother, Mrs. Todd exclaims, "There, you never get over bein' a child long's you have a mother to go to" (35). When a visit to Green Island inspires Mrs. Todd to tell the narrator about the young husband whom she lost at sea many years ago, the pennyroyal plot where they are sitting becomes a place closer to the spiritual world than to the "plain everyday world" (49). Similarly, when the narrator visits the remote island home of poor Joanna, a woman who died a hermit many years before, she experiences a sympathetic connection which allows her to see the world as Joanna must have seen it:

> But as I stood alone on the island, in the sea-breeze, suddenly there came a sound of distant voices; gay voices and laughter from a pleasure-boat that was going seaward full of boys and girls. I knew, *as if she had told me,* that poor Joanna must have heard the like on many and many a summer afternoon, and must have welcomed the good cheer in spite of hopelessness and winter weather, and all the sorrow and disappointment in the world. (82; emphasis mine)

Standing near the ruins of Joanna's home, the narrator sees the world, briefly, as she must have seen it. Although Joanna is long dead, with "eternity well begun" (82), sympathetic connection transcends time and death.

Time in Jewett's fictional world proceeds not linearly, but cyclically, blurring the lines between past and present. Jewett notes with tongue in cheek that, tending her garden, her heroine "trod heavily upon thyme" (3)—thus suggesting that Mrs. Todd's forays into her garden represent a break with ordinary time. As Romines notes, domestic activities in Jewett's world seem not to take place within ordinary time at all, but within a distinctly female version of mythic time. In *The Sacred and the Profane: The Nature of Religion,* Mircea Eliade describes sacred

time as *"by its very nature . . . reversible* in the sense that, properly speaking, it is *a primordial mythical time made present.* Every religious festival, any liturgical time, represents the reactualization of a sacred event that took place in a mythical past, 'in the beginning' . . . sacred time is indefinitely recoverable, indefinitely repeatable. From one point of view it could be said that it does not 'pass'" (68–69). In Dunnet Landing, domestic activities assume the status of religious rites. By practicing ancient domestic rituals, Mrs. Todd confuses the distinction between the spiritual and the temporal worlds, between an ancient past and the present.

Cyclical time in Jewett's Dunnet Landing also serves to blur the lines between life and death, the much-mourned dead maintaining a ghostly presence in the lives of those left behind. Frequently, it is domestic practice that summons these spirits. Elijah Tilley sustains memories of his beloved, much-mourned wife by keeping the household appointments "same's poor dear left 'em" (121). So vivid are these memories that, on lonely nights, Tilley finds himself watching for his "poor dear" at the door. Even the narrator is caught up in Elijah Tilley's domestic spell. Sitting in "the clean bright room which had once enshrined his wife, and now enshrined her memory," the narrator "began to see her [her]self in her home" (122). In Jewett's "The Foreigner," domestic ties create a similar bond between the living and the dead. At the deathbed of her young friend Mrs. Tolland, Mrs. Todd performs the long-standing domestic practice of "watching." In the moments before young Mrs. Tolland dies, both she and Mrs. Todd see the ghost of the dying woman's mother, who has come to take her over to the "other side." Far from being frightened, both Mrs. Todd and Mrs. Tolland understand the comforting nature of the visit:

> "You saw her, didn't you? . . . 'tis my mother. . . ."
> *"Yes, dear, I did; you ain't never goin' to feel strange an' lonesome no* more." An' then in a few quiet minutes 'twas all over. I felt they'd gone away together. (186)

More than a comfort on earth, the nurturance of mothers thus enacts a comforting presence that transcends even death.

While Jewett's text is profoundly concerned with spiritual matters, she, unlike most writers of sentimental fiction, dismisses conventional

religion as ineffectual at best and harmful at worst. In the story of "Poor Joanna"—a hermit-like woman who retreats to remote Shell Heap Island when she is jilted by her lover a month before their planned wedding—Jewett posits the comfort provided by the maternal Mrs. Todd against that offered by the local minister. A visit from the appropriately named Pastor Dimmick—a man whom Mrs. Todd considers "a vague person, well-meanin', but very numb in his feelin's"—is motivated not by the human sympathy that draws Mrs. Todd, but by his belief that Joanna "might wish to have him consider her spiritual state" (69–70). Pastor Dimmick reflects the traditional church's hierarchical design, which obliterates simple compassion by dictating that the minister act as an authority figure. Lacking Mrs. Todd's sensitive eye, he overlooks the worn Bible on Joanna's shelf and instead asks blunderingly "if she felt to enjoy religion in her present situation" (74). Mrs. Todd is indignant:

> "I wished he knew enough to just . . . read somethin' kind an' fatherly 'stead of accusin' her, an' then given poor Joanna his blessin' with the hope she might be led to comfort. He did offer prayer, but 'twas all about hearin' the voice o' God out o' the whirlwind; and I thought while he was goin' on that anybody that had spent the long cold winter all alone out on Shell-heap Island knew a good deal more about those things than he did." (75)

The church's religious hierarchy, however, rejects the authority of human experience, substituting instead the authority of the minister.

The little comfort that Joanna allows herself in her solitude is drawn not from conventional religion, but from domestic practice and female community. She has brightened her spare cottage with what comforts could be fashioned from her spartan surroundings: her walls are decorated with seashells and wildflowers, her floors covered with mats woven of grass. All alone on the remote island, she wears "a pretty gingham dress I'd often seen her wear before she went away," Mrs. Todd reports; "she must have kept it nice for best in the afternoons" (73). In seeking a source of comfort for Joanna, Mrs. Todd thinks not of religion, but of her own mother: "[T]he love in mother's heart would warm her," she muses, "an' she might be able to advise" (74).

Respecting Joanna's wish that she never be asked again to leave the island, Mrs. Todd merely sits quietly with Joanna for the remainder of her visit, holding her hand. In Jewett's world, the religion that comforts and sustains is one of mutuality rather than authority.

Joanna herself blames a harsh and unforgiving Calvinism for her retreat; as she tells Mrs. Todd, "I haven't got no right to live with folks no more. . . . I have committed the unpardonable sin . . . I was in great wrath and trouble, and my thoughts was so wicked towards God that I can't expect ever to be forgiven" (76). Mrs. Fosdick, who tells Joanna's story, however, rejects this religious explanation. The storyteller attributes Joanna's solitude not to religious devotion, nor even to her romantic disappointment, but to her thwarted plans for a life of domesticity: "All her hopes were built on marryin', an' havin' a real home and somebody to look to; she acted just like a bird when its nest is spoilt" (65–66). Jewett's poor Joanna thus seems less a religious recluse than a lone housekeeper who withdraws to a solitary domestic retreat rather than play the role of a jilted and disappointed lover in Dunnet Landing. Reverend Dimmick, Joanna's supposed spiritual advisor, can offer "no remedies" (77); Joanna's spiritual remedy must be a domestic one.

Joanna's death and funeral, too, are appropriately domestic. She is attended in her final illness by Mrs. Blackett, the consummate mother figure. Her funeral is presided over by the minister, but his sermon is drowned out by the singing of a sparrow, thoroughly tamed through long association with Joanna's gentle presence. While the minister is annoyed, Mrs. Todd surmises, "I wa'n't the only one thought the poor little bird done the best of the two" (78). After Joanna's death, her remote island becomes a spiritual retreat which links the temporal lives of Dunnet Landing to Joanna's life after death. The narrator, who initially sees Joanna's grim retreat as "something mediaeval" (69), comes to a greater understanding and empathy when she visits her grave on Shell Heap Island: "In the life of each of us . . . there is a place remote and islanded, and given to endless regret or secret happiness; we are each the uncompanioned hermit and recluse of an hour or a day; we understand our fellows of the cell to whatever age of history they may belong" (82). Indeed, the narrator is not the only person from Dunnet

Landing to feel drawn to the site of Joanna's retreat; the path to her grave is well worn by the feet of many "pilgrims" (81).

In the spiritual quest tradition, the hero must set forth into the wilderness alone in order to discover spiritual truth. The spirituality expressed by Jewett in *The Country of the Pointed Firs,* however, is collective, shared by a community of women with the stranger among them. As the narrator departs at the end of *Pointed Firs,* she takes with her a series of tokens which symbolize the spiritual gifts she has received during her summer in Dunnet Landing. The "affecting provision" Mrs. Todd has prepared for her friend's "seafaring supper" is a reminder of the domestic gifts of which she has partaken. The "neatly tied bunch of southernwood and . . . twig of bay" signify Mrs. Todd's healing arts and the fact that the narrator, too, has become a skilled gatherer of healing herbs (131). The coral pin recalls the story of poor Joanna and her solitary, spiritual retreat, as well as the loving friendship of the women who sustained her and, finally, laid her to rest. Through her gifts, Mrs. Todd invites the narrator to become a wise woman like herself, partaking of a spirituality centered in domestic practice.

In *The Bluest Eye,* Toni Morrison, like Jewett, creates a mythic world which suggests the spiritual dimensions of a domestic life. Juxtaposed with Claudia MacTeer's first-person narration are segments from a Dick and Jane reader which detail a stereotypical portrait of "perfect" domesticity: two parents (Mother is "very nice" while Father is "big and strong"), two children, two pets, a green and white house, much laughter and play. As excerpts from this story of domestic life recur throughout Morrison's text, however, they become increasingly distorted and frenetic, without punctuation or separation between words. The pristine, unconflicted life described in the Dick and Jane reader is foreign to Morrison's characters, who are poor and black. The harsh circumstances of her characters' lives distort both the form and the meaning of this tale of "perfect" domesticity, even as the lives of her characters are threatened and distorted by being held up to a model that has no meaning for them. In *The Bluest Eye,* Morrison creates a

revisionist tale of domestic life: although the MacTeer children live on the brink of poverty, their lives are rich with love, and they are nurtured both physically and spiritually. The Breedlove family's fate, by contrast, illustrates the horrific consequences when domestic life goes to ruin.

Morrison establishes the mythic nature of her text in its epigraph: "Quiet as it's kept, there were no marigolds in the fall of 1941," she begins (9). Just as *The Country of the Pointed Firs* begins with a return, Morrison's *The Bluest Eye* begins with a conclusion—the failure of the marigolds to bloom—whose meaning is gradually revealed to both narrator and reader. Time in *The Bluest Eye* thus proceeds cyclically; by naming her chapters after the successive seasons, Morrison suggests that this story is not linear, but one that will repeat itself, based as it is in the ongoing life of a community. As in Jewett's *Pointed Firs,* domestic life functions in *The Bluest Eye* as a ritual enactment, creating life-sustaining relationships within families and communities. Conversely, Morrison depicts the spiritual dissolution in a family whose home is devoid of domestic ritual.

Although Morrison's text, like Jewett's, is structured around family and community, home life in *The Bluest Eye* represents a dramatic departure from the idyllic domesticity of Jewett's Dunnet Landing. Poverty in Lorain, Ohio, in 1941 is not genteel, but cold, dirty, and cruel. The MacTeers live just on the edge of that poverty, and remaining outside its whirlpool of dissolution and decay requires constant vigilance. Because childhood illnesses threaten unanticipated worry and expense, they are treated not with tenderness, but with "contempt" (13). When she is scolded and put to bed for coming home with a cold, Claudia does not understand that her mother "is not angry at [her], but at [her] sickness" (14). As an adult looking back on those childhood winters, however, Claudia recognizes the healing quality of domestic care:

> But was it really like that? As painful as I remember? Only mildly. Or rather, it was a productive and fructifying pain. Love, thick and dark as Alaga syrup, eased up into that cracked window. I could smell it—taste it—sweet, musty, with an edge of wintergreen in its base—everywhere in that house. It stuck, along with my tongue, to the frosted windowpanes. It coated my chest, along

with the salve, and when the flannel came undone in my sleep, the clear, sharp curves of air outlined its presence on my throat. And in the night, when my coughing was dry and tough, feet padded into the room, hands repinned the flannel, readjusted the quilt, and rested a moment on my forehead. So when I think of autumn, I think of somebody with hands who does not want me to die. (14)

For Morrison, maternal love is not romantic and ethereal, but dark, medicinal, and mysterious. She casts the "everyday" task of caring for a child in terms which suggest other-worldly power: the ability to sustain life. This power, likewise, is described in domestic terms, permeating the house like the smell of cooking. Both Morrison and Jewett thus depict domestic tasks as sacred rituals with potential to enact the spiritual.

Domestic life in Lorain, as in Dunnet Landing, is an almost exclusively female domain in which men play peripheral roles. Claudia and Frieda's father receives only brief mention in his grim determination to keep the house warm during a bitter Ohio winter. Those who establish the domestic rhythms of the home and nurture life on a daily basis, however, are women. As Morrison describes the women snapping beans, boiling sheets, and performing the dozens of other domestic chores that sustain the lives of their households, she transforms these communal rituals and the conversations that accompany them into sacred rites:

Their conversation is like a gently wicked dance: sound meets sound, curtsies, shimmies, and retires. Another sound enters but is upstaged by still another: the two circle each other and stop. Sometimes their words move in lofty spirals; other times they take strident leaps, and all of it is punctuated with warm-pulsed laughter—like the throb of a heart made of jelly. The edge, the curl, the thrust of their emotions is always clear to Frieda and me. We do not, cannot know the meanings of all their words, for we are nine and ten years old. So we watch their faces, their hands, their feet, and listen for truth in timbre. (16)

As Sara Ruddick points out in *Maternal Thinking,* these female conversations, often dismissed as gossip, are actually a way of knowing and creating knowledge. The MacTeer children learn from overhearing the women's talk that domestic life is full of mysterious rituals and fraught

with secret meanings to be deciphered. It is a communal life, shared primarily by women, whose collective responsibility is to sustain the lives of husbands and children. The conversations among Morrison's women serve as a way of sharing knowledge within the community and forming a communal response to it.

While one strand of Morrison's parable describes the sustaining power of the MacTeers' communal, domestic life, the other establishes the horrors of a family living without community or domestic ritual. Through the degeneracy of Cholly Breedlove, his wife and children have ended up "outdoors"—a condition partly physical, but mainly spiritual, which Morrison describes in razor-sharp detail:

> Outdoors, we knew, was the real terror of life. The threat of being outdoors surfaced frequently in those days. Every possibility of excess was curtailed with it. If somebody ate too much, he could end up outdoors. If somebody used too much coal, he could end up outdoors. People could gamble themselves outdoors, drink themselves outdoors. . . . To be put outdoors by a landlord was one thing. . . . But to be slack enough to put oneself outdoors, or heartless enough to put one's own kin outdoors—that was criminal.
>
> There is a difference between being put *out* and being put out*doors*. If you are put out, you go somewhere else; if you are outdoors, there is no place to go. The distinction was subtle but final. (17–18)

"Outdoors" thus refers not only to the physical condition of having nowhere to sleep but, more importantly, to the spiritual state of homelessness. The Breedloves live in such a state of degeneracy that they have no sense of belonging either to themselves, as a family, or to the community. Ten-year-old Pecola and her brother, Sammy, call their mother Mrs. Breedlove, suggesting the complete absence of a maternal relationship. In stark contrast to the tightly communal life of the MacTeers, each of the Breedloves lives "in his own cell of consciousness . . . collecting fragments of experience here, pieces of information there" (31).

In keeping with Morrison's mythic tone, everything about the Breedloves' external lives proclaims their despairing internal condition; their spiritual ruin is manifested in domestic ruin. The Breedloves live in a bleak, abandoned storefront, and even their furniture—a couch

bought new but delivered with a great tear already across its back—
suggests despair:

> If you had to pay $4.80 a month for a sofa that started off split, no
> good, and humiliating—you couldn't take any joy in owning it.
> And the joylessness stank, pervading everything. The stink of it
> kept you from painting the beaverboard walls; from getting a
> matching piece of material for the chair. . . . It withheld the
> refreshment in a sleep slept on it. It imposed a furtiveness on the
> loving done on it. Like a sore tooth that is not content to throb
> in isolation, but must diffuse its own pain to other parts of the
> body—making breathing difficult, vision limited, nerves unsettled,
> so a hated piece of furniture produces a fretful malaise that asserts
> itself throughout the house and limits the delight of things not
> related to it. (32–33)

The Breedloves' kitchen serves as a battleground rather than as the cen-
ter of domesticity. The sound of dishes rattling in the morning signi-
fies not the sustaining ritual of meal preparation, but Mrs. Breedlove's
attempt to awaken her drunken husband so as to finish a quarrel from
the night before. Sharing a bedroom with her parents, Pecola interprets
the sounds of their lovemaking as "choking sounds and silence" (49)—
an apt metaphor for their violent, fragmented domestic life.

As she chronicles Cholly Breedlove's deterioration, Morrison
rewrites the quest into the wilderness that is the mark of spiritual free-
dom for the canonical hero. Whereas, in the traditional male quest
myth, freedom from communal ties leads to spiritual discovery, for
Cholly it leads to dissolution. Raised by his grandmother, Cholly is set
adrift in a spiritual wilderness when she dies. When he meets Pauline,
he is in a "godlike" state of complete detachment from domestic life
(126); their marriage is soon "shredded with quarrels" (94) and he is left
with no idea how to raise his children, "having never watched any par-
ent raise himself" (126). Ironically, although Cholly tries to free him-
self from domestic responsibility, his degeneracy becomes his children's
inheritance; his flight from domestic life leads to the novel's central
tragedy. While Morrison depicts women as the creators and caretakers
of home, she also suggests that home is vital to the lives of both women
and men.

In *The Bluest Eye,* an essential function of home is as a sanctuary from sexual violence. Morrison contrasts the home life of the MacTeers and the Breedloves by detailing their responses when first Frieda, then Pecola, is threatened with sexual abuse. In order to help pay the bills, the MacTeers take Mr. Henry into their home as a boarder. The MacTeers' innocent faith in the inviolability of their home is mirrored in their failure to recognize Mr. Henry as a probable pedophile: never married, a "steady worker with quiet ways," he seduces the children with magic tricks, jokes, and stories (16). Claudia and Frieda adore him, and their parents smile their approval as the children search "all over him" for ice cream money, "poking [their] fingers into his socks, looking up the inside back of his coat. . . . [their] hands wandering over Mr. Henry's body" (17). When Mr. Henry molests Frieda, however, the loyalty of her family and neighbors are clear as they rush to protect and avenge her. Knowing that her parents will support her, Frieda runs to them immediately, thus preventing Mr. Henry's violence from escalating:

> "I told Mama, and she told Daddy, and we all come home . . . Daddy . . . threw our old tricycle at his head and knocked him off the porch. . . . Then Mama hit him with a broom. . . . And Mr. Buford came running out with his gun . . . and Daddy shot at him and Mr. Henry jumped out of his shoes and kept on running in his socks." (80)

Surrounded by a fiercely protective domestic love, Frieda recovers fully and almost immediately from this frightening violation.

When Cholly Breedlove rapes and impregnates his daughter, however, both her own mother and the community withhold any comfort. Pauline discovers Pecola unconscious on the kitchen floor, her gray panties around her ankles, and responds by beating her so severely that, as one neighbor observes, "she lucky to be alive herself" (148). More confusing to Claudia and Frieda than this cruelty from Pecola's mother, however, is the withholding of any sympathy or affection by the neighborhood women: "They were disgusted, amused, shocked, outraged, or even excited by the story. But we listened for the one who would say, 'Poor little girl,' or 'Poor baby,' but there was only head-wagging where those words should have been. We looked for eyes creased with concern, but saw only veils" (148). Denied the

affection or sympathy of a protective home, Pecola recovers physically, but is broken spiritually, finally deteriorating into madness.

Deprived of an ordered and sustaining domesticity in her own home, Pecola's mother, Pauline, creates this order in the home of her employers—a well-to-do white family, the Fishers. In her own home, Pauline, victimized by poverty and despair, has given up trying to care for her family in the midst of ugliness and need. At the Fishers, however, she reigns over a fully stocked pantry and a bright, clean kitchen, bathes the blond-headed Fisher girl with endless quantities of clear, hot water in a tub made of porcelain rather than zinc, and reaps the praise reserved for an "ideal servant" (101). As Trudier Harris argues in *From Mammies to Militants: Domestics in Black American Literature,* Pauline's immersion in and identification with the Fisher family reveals a pathological rejection of her own blackness and an identification with a role defined for her by a dominant white culture.

Pauline embraces her role as the Fishers' maid not only out of self-hatred and deprecation, however, but because this role meets her need for domestic order. Pauline is a born housekeeper; as a young teenager she embraced the role of homemaking and caring for her two young siblings while the rest of the family worked outside the home. Only fantasies of romantic love—ultimately an ideology as destructive to Pauline as the "servant" role she embraces—cause her to lose interest in the satisfaction of preserving domestic order. When her romance with Cholly sours and her interest in housekeeping returns, she finds herself in the midst of a poverty so destroying that it cannot be overcome by her attempts to create a home. Pauline thus fulfills her psychological need for domestic order by using the rich resources of the Fisher household. A domesticity performed as servitude, and to the detriment of care for one's own children, however, is devoid of any spiritual dimension. When Pecola comes to the Fisher home and spills a hot homemade pie on the floor, her mother slaps her nearly senseless as she cries repeatedly, "my floor . . . my floor" (87). Morrison thus makes clear Pauline's complete abandonment of her natural role as Pecola's mother and her distorted identification with the Fisher household.

In *The Bluest Eye,* Morrison, like Jewett, rejects conventional religious practice as a source of comfort or healing. Pauline's religious faith

only fills her with venom toward Cholly and allows her to continue avoiding domestic responsibility toward her family. At church, she "moaned and sighed over Cholly's ways. . . . Holding Cholly as a model of sin and failure, she bore him like a crown of thorns, and her children like a cross" (100). In keeping with traditional Christian beliefs, Pauline dismisses the importance of her earthly life, looking forward instead to "glory" after death (104). For Pauline, religion thus serves as an escapist myth rather than an impetus toward care.

As she rewrites the spiritual quest myth, placing home at its center, Morrison also redefines home. While Pecola is abused by her own family, she is lovingly embraced by a "family" of prostitutes who live above the Breedloves, women who offer Pecola far more charity and maternal concern than she receives at home. Although they are social outcasts, these women share a communal life of stories, conversation, and mutual care and extend an almost maternal sympathy toward the "motherless" child, Pecola. By contrast, Morrison describes the distortion of domesticity in a "Christian" household where domestic life has created an "inviolable world" (69). Geraldine, the mother of one of Pecola's classmates, sees in Pecola the embodiment of the "nigger" identity from which she tries to preserve her family. In Geraldine's home, domesticity and maternal nurturance are distorted by race hatred:

> Colored people were neat and quiet; niggers were dirty and loud. [Her son] belonged to the former group: he wore white shirts and blue trousers; his hair was cut as close to his scalp as possible to avoid any suggestion of wool, the part was etched into his hair by the barber. In winter his mother put Jergens Lotion on his face to keep the skin from becoming ashen. Even though he was light-skinned, it was possible to ash. The line between colored and nigger was not always clear; subtle and telltale signs threatened to erode it, and the watch had to be constant. (71)

When Geraldine finds Pecola in her home, she sees not an impoverished and lonely child in need of mothering, but a nigger. "Get out," she says quietly. "You nasty little black bitch. Get out of my house" (75). In contrast to the true domestic hospitality offered by Mrs. MacTeer, Geraldine's version of domesticity is narrow and exclusionary, suggesting hatred not only of Pecola, but of her own blackness.

A similar self-hatred contributes to Pecola's ultimate destruction and provides further contrast between her life and that of the well-loved Claudia MacTeer. Claudia disdains her annual Christmas gift of a blond, blue-eyed baby doll: "Adults, older girls, shops, magazines, newspapers, window signs—all the world had agreed that a blue-eyed, yellow-haired, pink-skinned doll was what every girl child treasured" (20). Puzzled by the mysterious attraction that so eludes her, Claudia dismembers one of the dolls in a spirit of both vengeance and curiosity: "To see of what it was made, to discover the dearness, to find the beauty, the desirability that had escaped me, but apparently only me" (20). Although the adults around her scold Claudia for ruining the doll, her rejection of its foreignness in fact reflects her regard for her own culture and her secure place within it. Rejecting the doll as a Christmas gift, Claudia longs instead for a day of complete absorption into the safety of family and home:

> I did not want to have anything to own, or to possess any object. I wanted rather to feel something on Christmas day. . . . "I want to sit on the low stool in Big Mama's kitchen with my lap full of lilacs and listen to Big Papa play his violin for me alone." The lowness of the stool made for my body, the security and warmth of Big Mama's kitchen . . . (21)

Claudia thus casts home life and domestic space as sacred, both offering a connection to family that effects positive transformation.

Pecola, however, who lacks Claudia's sense of connection to family and community, embraces unquestioningly the white standard of beauty and desirability that Claudia rejects. When she arrives at the MacTeers, Pecola's complete isolation and lack of care is signaled by her empty-handedness. Claudia recognizes that even a poor child would ordinarily have arrived with a "little paper bag with the other dress, or a nightgown, or two pair of whitish cotton bloomers." Pecola, however, "came with nothing" (19). She fills the enormous void in her life with a complete devotion to Shirley Temple, whose blond hair, blue eyes, and dimpled, pink cheeks are pictured on a cup in Claudia's house. Pecola seizes every opportunity to drink from this cup, her insatiable thirst for milk suggesting her desperate need for mothering. Pecola's obsession with Shirley Temple signals a self-hatred that ultimately leads

to her ruin. Her last wish, before her father's attack and her subsequent breakdown, is to have the blue eyes of a white child.

Kaye Gibbons' *Ellen Foster,* like Morrison's *The Bluest Eye,* gives mythic dimension to a story of domestic life gone wrong. The novel's first line both evokes and fractures the incantatory "once upon a time" of myth: "When I was little," eleven-year-old Ellen reflects, "I would think of ways to kill my daddy" (1). Like Morrison's stunted marigolds, the child who dreams of killing her own father represents a distortion of natural order. In keeping with mythic tradition, Ellen views the events of her life as having supernatural significance; her fractured domestic life serves as a symptom of spiritual disorder. Raised by an alcoholic father and a sickly mother, she describes her family's deterioration in apocalyptic terms: "Everything was so wrong like somebody had knocked something loose and my family was shaking itself to death. Some wild ride broke and the one in charge strolled off and let us spin and shake and fly off the rail" (2). For Ellen, her family's degeneration is a cosmic event suggesting abandonment by "the one in charge." Similarly, the relatives who fail to protect Ellen are not merely uncaring; they are personifications of evil. "She had some power," Ellen says of her hateful maternal grandmother. "Without saying one word she could make my bones shake and I would think of ghost houses and skeletons rattling all in the closets. Her power was the sucking kind that takes your good sense and leaves you limp like a old zombie" (68).

For Ellen's mother, as for Pauline Breedlove, romantic love is a destructive trap which leads to her downfall. Ellen reveals her father's ruinous effect on her mother's life when she confuses romance with illness: "She could not help getting sick but nobody made her marry him. You see when she was my size she had romantic fever I think it is called and since then she has not had a good heart" (3). For Ellen, the love that sustains and preserves life is domestic love. While her mother is ill, Ellen cleans the house and fixes the meals, disdaining her father for his failure to provide care: rather than "bringing her food to nibble on and books to look at," he is "taking care of his own self" (6). When her

mother commits suicide by taking an overdose of her heart medication, Ellen crawls into bed beside her, prolonging this last moment of maternal care: "I always want to lay here. And she moves her arm up and I push my head down by her side. And I will crawl in and make room for myself. My heart can be the one that beats" (10).

In Gibbons' *Ellen Foster,* as in Jewett's *Pointed Firs,* home life is deeply rooted in memory, sustaining connection between the living and the dead. Her memories of her mother are cast in biblical terms: "[M]y mama . . . liked to work in the cool of the morning. She nursed all the plants and put even the weeds she pulled up in little piles along the rows. . . . Weeds do not bear fruit" (49). After her mother has died, Ellen's few memories of her serve as parables, providing life lessons for a child without a mother to guide her:

> I know I have made being in the garden with her into a regular event but she was really only well like that for one season.
>
> You see if you tell yourself the same tale over and over again enough times then the tellings become separate stories and you will generally fool yourself into forgetting you only started with one solitary season out of your life.
>
> That is how I do it. (49)

Like Claudia and Frieda MacTeer, Ellen studies her mother's domestic practices in order to learn lessons to live by. Sustained in Ellen's memory, the spiritual truths imparted by her mother transcend even death.

In *Ellen Foster,* as in *The Bluest Eye,* home life is threatened by sexual violence. After her mother dies, Ellen's father turns his abuse on her, calling her by her mother's name. While Pecola is driven to madness by her father's violence, however, Ellen flees her home in search of safety. For Ellen, unlike the canonical American hero, homelessness represents not freedom, but spiritual oblivion. Although she does embark on a quest, it is not the canonical hero's flight *from* home and the restrictions it imposes, but a flight *to* home and its promise of physical and spiritual nurturance. Ellen's quest is not linear, but circular; she flees her own home in order to seek one that will nurture her both physically and spiritually.

Living essentially alone except for her father's occasional drunken visits, Ellen, like the canonical Huck Finn, is a child free of parental restrictions. Unlike Huck, who revels in his freedom, however, Ellen

strives to duplicate a "normal" family life for herself. As Katherine Rabuzzi writes in *The Sacred and the Feminine,*

> the ritual enactment of housekeeping typically links its performer back in time to the company of female ancestors. Such linking back to origins is a frequent and important element of most religious ritual. Just as family stories or memorabilia may be handed down within families, so may traditional ways of doing certain tasks. (102)

Following her mother's example, Ellen compensates for her lack of a home and family by "mothering" herself while she waits for a new home. Alone, she plays "family," cutting out pictures of a man, a woman, and children and outfitting them with cut-out domestic comforts from the Sears catalog. When she joins the Girl Scouts, Ellen plays the role of her own parent: "[I] sign[ed] my daddy's initials saying I had made a handicraft or wrapped a ankle or whatever the badge called for" (Gibbons 27). Although she gives up on trying to replicate the meals served in the cafeteria at school, she chooses the food that most resembles, for her, a proper meal: "I found the best deal was the plate froze with food already on it. A meat, two vegetables, and a dab of dessert" (25). Taking control of her own destiny, Ellen defines and enacts her future happiness in domestic terms: "I decided that if I quit wasting time I could be happy as anybody else in the future. . . . And that is what I did. That is why I think I am somebody now because I said by damn this is how it is going to be and before I knew it I had a new mama" (95).

In Gibbons' fictional world, spiritual truth is revealed not in a solitary wilderness quest, but through connections with home and family. When Ellen spies her potential "new mama" in church, she races home to "write down ways and tricks of how to have her" (57). As the story's narrative line fluctuates between past and present, descriptions of domestic comforts form a constant thread. The details of her eventual home with her "new mama" are recounted in loving detail:

> Look around my room. It is so nice.
> When I accumulate enough money I plan to get some colored glass things that you dangle from the window glass. I lay here and feature how that would look. I already got pink checkerboard

curtains with dingleballs around the edges. My new mama sewed them for me. She also sewed matching sacks that I cram my pillows into every morning.

Everything matches. It is all so neat and clean. (5)

Equally as important as these comforts is the food that her new mama prepares: "There is a plenty to eat here and if we run out of something we just go to the store and get some more" (2). At breakfast, Ellen compares her own plate to the one pictured on the cereal box, noting with satisfaction that "it all matches" (82). Following a life in which "[t]he only hard part was the food" (25), nothing is so important to Ellen as the certainty of prepared meals and a family with whom to share them. In Gibbons' text, a true home—one offering both physical safety and an essential sense of connection to others—represents the fulfillment of all desire.

Although Ellen's homelessness represents both physical and spiritual deprivation, Gibbons, like Jewett and Morrison, depicts conventional religion as ineffectual in providing comfort. The minister who performs her mother's funeral service is as blundering and superficial as Jewett's Reverend Dimmick, and Ellen easily sees through his hypocrisy:

I do not know this preacher. He says that even though he did not know my mama he feels like he knew her well because he has met us and we are all so nice. It does not bother him that what he said does not make good sense.

And what else are you going to say when the Bible comes flat out and says killing yourself is flinging God's gift back into his face and He will not forgive you for it ever? The preacher leaves that out and goes straight to the green valleys and the streets of silver and gold. (20)

For Ellen, the easy platitudes of conventional religion provide neither help nor comfort. When she learns that her new mama receives financial support from a local congregation, she accepts her obligations pragmatically: "You go in that church and act genuine. Even if you think what he has to say that week is horse manure or even if you believe it is a lie you sit there and be still. Worse could happen than for you to sit for an hour. You could be where you came from" (56).

Living with her new mama, Ellen learns that true spiritual fulfill-
ment comes not during church, but after the service: "When or if you
come to my house now after church you will smell all the things that
have been simmering on low. It has been waiting for me and me for
it" (58). Indeed, on Sundays food preparation becomes a communal
activity that is at the heart of Ellen's new domestic life:

> Everything we do almost on Sundays has to do with food.
> When we finish the meal on hand it is time to prepare chicken
> salad, ham salad, bread, three bean soup, or what have you for that
> week's lunch boxes. . . . Everybody like me, Stella, Francis, my
> new mama, Jo Jo, but not the baby are involved in this Sunday
> cooking. (58)

In comparison to the Sunday dinner and rich domestic ritual that fol-
lows the service, churchgoing is an empty tradition. For Ellen, spiritual
comfort is not sought in church, but created in the home.

In searching for healing from her past, Ellen rejects traditional psy-
chological remedies as well as conventional religion. On Tuesdays,
Ellen notes, "[My new mama] squeezes me extra hard . . . because she
knows that is my tough day of the week."

> Every Tuesday I try to think of an exotic disease that will sound
> deadly enough to keep me out of school. That is the day when
> the man comes and asks me questions about the past.
> I always dread him. (86)

For Ellen, visits with the school psychologist are marked by his inexpli-
cable questions and her duplicity; she is prevented from telling the truth
by accusations of defensiveness and his twisting of her words "like a
miracle into exactly what he wanted me to say" (86). Like Jewett's poor
Joanna, Ellen requires not the professional care of a minister or psy-
chologist, but the loving care of a mother. "[T]here have been more
than a plenty days," Ellen says of her new mama, "when she has put
both my hands in hers and said if we relax and breathe slow together I
can slow down shaking. And it always works" (121). Her new mama's
"cure" for Ellen's troubles lies in such nurturing activities as washing
Ellen's hair ("I feel her long fingers on my head and pray that it takes a

long time for me to be clean," Ellen confesses), sewing and cooking for her, and including her in the communal activities of the household (36).

In establishing family and domestic life as sources of the sacred, Gibbons, like Morrison, redefines home and family. Rather than protecting and nurturing her, Ellen's own relatives serve as the greatest threat to her safety. After her mother's death, Ellen's father fails to provide for her most basic needs; he does not feed her, neglects to pay the power bill, and, when the weather turns cold, it is her friend Starletta's father who has the heat turned on for Ellen and who buys her a new winter coat. When her father and his friends make their sporadic visits, Ellen is affronted at this invasion of her domestic space: "Who said they could come in my house and have a free-for-all?" she wonders. "Who said they could be here?" (37). Her home no longer a sanctuary, Ellen first hides from her father in her closet, then flees the house altogether when he sexually assaults her. Home in *Ellen Foster,* as in *The Bluest Eye,* is not an inherently sacred space, but is made sacred by domestic activities that nurture, protect, and sustain life. In the absence of such domestic ritual, home becomes vulnerable to violence and neglect.

As Ellen searches for a new home, her other relatives also prove inadequate at providing domestic care. Ellen describes the few days she spends with her Aunt Betsy as a scene of domestic bliss:

> All afternoon and night and on into the next day is like magic.
> I do not think of anything but the flowers on the sheets and the
> bubbles in the bath water.
> This is the life.
> All day Sunday we just lounge around the house . . . Aunt
> Betsy . . . just smiles and tells me to make myself right at home.
> Which I do. Looking in the dresser drawers. Fingering the
> what-nots. Generally getting to know the place. (41)

Her sanctuary at Aunt Betsy's house is temporary, however, and Ellen must return to her own home and try to elude her father's sexual advances. While her Aunt Nadine does offer Ellen a home, she does so grudgingly, treating Ellen as an outcast. This time, however, Ellen has no illusions that Nadine's house will provide a real home: "I will treat this like a hotel I told myself. I will stay for a while until I find the next

place maybe with God's help but more than likely without it" (94). Ellen thus locates spirituality not in the figure of a transcendent God, who may or may not intervene on her behalf, but in the certain comfort of home.

The court finally places Ellen with her maternal grandmother, whose unsuitability as a mother figure is signified by Ellen's description of her house as a "museum" full of "what-nots" that she is forbidden to touch. Unlike Aunt Betsy, who had welcomed Ellen's interest in her home, her grandmother "would catch me snooping around sometimes and say to me I'll break your little hand if you touch that vase! Not joking but serious to make me think of how a broke hand might feel" (62). Even the meals her grandmother serves signify the gulf between the two. Most days, Ellen comes home to find a plate left for her in the kitchen. On Sundays, however, when she and her grandmother share the dinner table, she explains, "[W]e both picked at our little individual chickens or turkeys and did not talk" (66). Compared to the communal tradition that accompanies meal preparation at her new mama's house, mealtime in her grandmother's home reflects the absence of a true family life.

While Ellen's own family treat her as an outcast in their homes, she is lovingly embraced by a variety of alternative families. When she is placed in a temporary home with her art teacher and her husband, Ellen observes longingly, "[T]he three of us could pass for a family on the street" (55). With Julia and Roy, Ellen is able to relax for the first time, within the protecting space of a loving home:

> [Julia] said it was good I loosened up. We would run around and she would tell me to let it all hang out. Let your hair down good golly Miss Molly let it all hang out. Go with the flow, she would say. Make up a tune and throw in some words and go with the flow.
>
> I had no idea people could live like that. (47)

Although they are infinitely more suitable than Ellen's own relatives, the court takes Ellen from this invented family. "What do you do when the judge talks about the family society's cornerstone but you know yours was never a Roman pillar but is and always has been crumbly old

brick?" Ellen wonders. "He had us all mixed up with a different group of folks" (56).

Gibbons' Ellen Foster, like Morrison's Pecola Breedlove, must seek domestic nurturance and familial love from unconventional sources when traditional definitions of home and family prove inadequate. One of Ellen's most reliable sources of care comes from her friend Starletta's family. From her own lonely home, Ellen watches the smoke rising from Starletta's chimney, musing, "You know it is a warm fire where the smoke starts" (29). Because Starletta is black, however, Ellen's need to be nurtured by this alternative family conflicts with the racial prejudice she has inherited from her community. When Ellen's father abuses her, she turns instinctively to the safety of Starletta's home: "Run down the road to Starletta. Now to the smoke coming out of the chimney against the night sky I run" (38). Although Starletta's parents offer her food and a place to sleep, however, Ellen is unable to accept their domestic nurturance; she refuses the "colored biscuit" Starletta offers and sleeps fully dressed on top of the covers (32). "As fond as I am of all three of them I do not think I could drink after them," Ellen worries (29).

In order to find a suitable home, Ellen must reshape her definition of family. While staying at her grandmother's house, Ellen is cared for by Mavis, a black servant who tells her stories of her own mother and shields her from her grandmother's cruelty. Each evening, Ellen walks to Mavis's house to watch her and her family. Seeing their care for one another, Ellen begins to reconsider her understanding of family:

> I started a list of all that a family should have. Of course there is the mama and the daddy but if one has to be missing then it is OK if the one left can count for two. . . .
>
> While I watched Mavis and her family I thought I would bust open if I did not get one of them for my own self soon. Back then I had not figured out how to go about getting one but I had a feeling it could be got. (67)

As she gains experience with her own neglectful family and with the outsiders who provide care for her, Ellen gradually revises this list. Later, living with her new mama, she muses, "When I stayed with my mama's mama I made a list of all that I wanted my family to be and I put down

white and have running water. Now it makes me ashamed to think I said that" (85).

Ellen celebrates her new definition of home and family by inviting Starletta to visit her in her new home. The change this reflects in Ellen is signified by the tremendous importance she attaches to the visit: "All that mattered in my world at that second was my new mama and the sound of yes in my ears oh yes Starletta is welcome here" (99). Ellen's preparation for Starletta's visit is a series of domestic rituals: she cleans the house, dictates the supper menu, and has her new mama embroider Starletta's initials on a set of towels. Anticipating the visit, Ellen reflects on her own transformation:

> I wonder to myself am I the same girl who would not drink after Starletta two years ago or eat a colored biscuit when I was starved?
>
> It is the same girl but I am old now I know it is not the germs you cannot see that slide off her lips and on to a glass then to your white lips that will hurt you or turn you colored. What you had better worry about though is the people you know and trusted they would be like you because you were all made in the same batch. You need to look over your shoulder at the one who is in charge of holding you up and see if that is a knife he has in his hand. (85)

Remembering her own recent prejudices, Ellen decides, "I will tell you it is hard and not one bit decent to keep on with that sort of thinking when you have seen all this world has to offer" (100). What the world has offered Ellen is a traditional home that failed to provide the care she needed and a series of alternative homes which, once she abandoned traditional conceptions of home and family, offered her needed safety and comfort.

Ellen reaches the end of her quest when she finds both physical safety and spiritual comfort at the home of her "new mama" and "her girls." Lying on her bed in her new room, Ellen describes this domestic scene as one of peace and rest:

> And while she fixed supper I unpacked my box and laid down to look out the window. I was glad to rest. My arms were sore

from toting the box and even when I laid out flat and still my legs felt like they were walking again. But I would not move ever from there.

 I have laid in my bed many many days since that first after-noon I heard her in the kitchen and I am always as glad to rest as I was then. (120)

For Ellen, spiritual quest has represented not adventure, but an exhaust-ing search for home. She signifies her integration into this domestic life by signing her school papers with a new name:

"That may not be the name God or my mama gave me but that is my name now. Ellen Foster . . . Before I even met Stella or Jo Jo or the rest of them I heard they were the Foster family. Then I moved in the house and met everybody and figured it was OK to make my name like theirs. Something told me I might have to change it legal or at church but I was hoping I could slide by the law and folks would think I came by the name natural after a while." (88)

In choosing her name, Ellen rejects the authority of both the courts and the church. Her new name signifies instead the authority of her own experience: no longer alone in the world, nor the daughter of an abu-sive father, she belongs to a loving home of her own choosing.

 In *Ellen Foster,* as in *The Country of the Pointed Firs* and *The Bluest Eye,* home and domesticity serve as sources of spiritual truth. Ellen dis-covers her spiritual home not by questing, but by turning inward to discover a new definition of home and family. As she had predicted, Ellen discovers her new home "maybe with God's help but more likely without it." Spiritual nurturance in *Ellen Foster* is found not in church, but in the female community to which Ellen flees. Ellen's world, like that of Jewett's Dunnet Landing and Morrison's Lorain, Ohio, is a female world in which men play roles that are peripheral at best, threat-ening and destructive at worst. The home to which Ellen flees offers no father, only a "new mama" and "her girls." To Ellen, this female-centered home is a utopia, offering physical safety and bringing about healing transformation.

Chapter III

Spiritual Communities

We know now we have always been in danger
down in our separateness
and now up here together but till now
we had not touched our strength
 —Adrienne Rich

The Adamic story which dominates the American literary canon is a story of self: the heroic individual on a quest from the constraints of communal life to individual fulfillment and enlightenment. Indeed, this narrative form both reflects and helps to construct the myth of the individual which dominates Western culture. In Western thought, all major theories of psychological development focus on the individual; within these theories, development is measured by increased individuation and separation from community. In Western theology, similarly, the journey to spiritual truth is a solitary one. "Since traditional spirituality has been male-centered, it has been regarded as an extension of the male maturational process that emphasizes individuation—coming into self-hood," theologian Carol Ochs writes (2). Fiction which represents individual quest and the flight from community as prototypical American experiences both reflects these dominant theories and reinforces the cultural myth they represent.

In an important essay, Sandra Zagarell names "narrative of community" as a genre which questions the novel form and its privileging

of the individual. Narratives of community, Zagarell writes, "take as their subject the life of a community . . . and portray the minute and quite ordinary processes through which the community maintains itself as an entity. The self exists here as part of the interdependent network of the community rather than as an individualistic unit" (499). According to Zagarell, narrative of community emerged as a genre in the mid-nineteenth century. In theorizing about why these works have not been examined as a generic body of literature before—indeed, why many of them have been overlooked entirely—Zagarell postulates that their departure from traditional novel forms has rendered them something of a narrative puzzle. Given the dominance of the novel form, "fictions about modes of life that are collective, continuous, and undramatic . . . are puzzling," Zagarell writes. "[R]eaders either assume that the work has no story, often delegating it to the supposedly inferior category of the sketch, or impose familiar but inappropriate notions of linear plotting on it" (505).

Although Zagarell includes such modernist works as Sherwood Anderson's *Winesburg, Ohio* and Jean Toomer's *Cane* within the genre, narrative of community is a form dominated by women writers. Zagarell offers a largely socio-historical explanation for this phenomenon, citing women's greater connection with pre-industrial life during and after the rise of industrialism in the mid-nineteenth century. Writers such as Elizabeth Gaskell, George Eliot, Harriet Beecher Stowe, and Sarah Orne Jewett wrote in order to preserve "the patterns, customs, and activities through which, in their eyes, traditional communities maintained and perpetuated themselves," Zagarell writes (500). The communal quality of women's lives, however, remains an intrinsic part of women's culture even in the twentieth century. Indeed, "narratives of community" have many qualities which mirror the often fragmented, episodic, and repetitive characters of women's lives.

One characteristic which differentiates narratives of community from the traditional novel form, Zagarell notes, is that these texts often "ignore linear development or chronological sequence and remain in one geographic place. Rather than being constructed around conflict and progress, as novels usually are, narratives of community are rooted in process" (503). This circular, episodic pattern is found in both nine-

teenth- and twentieth-century narratives of community. In Sarah Orne Jewett's *The Country of the Pointed Firs,* while Mrs. Todd and the narrator frequently journey into the country to visit friends, care for Mrs. Todd's "patients," or gather herbs, these journeys are always circular, ending back at Mrs. Todd's home with a discussion of the day's events. The purpose of the journey, therefore, is not to break from the restrictions of community, but to strengthen community. In Harriette Arnow's *The Dollmaker,* the plot is superficially structured around quest: Clovis Nevels' journey from the rural South to the "promised land" of the industrial north. Gertie Nevels' story, however, focuses on her struggle to preserve community in spite of forces that threaten it. Alice Walker's *The Color Purple,* like Jewett's *Pointed Firs,* centers around the female protagonist's journey from isolation to community. Celie's quest lies not in fleeing community, but in gathering others into the community that she forms on her front porch. And in Toni Morrison's *Beloved,* as in Arnow's *The Dollmaker,* the female protagonist seeks to recreate community when it is threatened by external forces. The story at the center of Morrison's text is not the linear flight from slavery, but the circular journey to recreate a community destroyed by slavery.

Narratives of community, unlike the novel, Zagarell notes, are not plot-driven, but "episodic"; they are "built primarily around the continuous small-scale negotiations and daily procedures through which communities sustain themselves." Because these narratives focus on the community rather than the individual, "characterization typically exemplifies modes of interdependence among community members." This "interdependence" includes a shared language: "readers are urged to recognize local language and activities like washing and gardening as both absolutely ordinary and as expressions of community history and values" (503). In Jewett's *The Country of the Pointed Firs,* her characters' days are filled with the "ordinary" activities that sustain physical and spiritual life: gardening, cooking, visiting. In order to be integrated into the community, the narrator/visitor must learn to participate in these activities by serving as an apprentice to Mrs. Todd. Accordingly, by the end of *Pointed Firs* the narrator has become a skilled herbalist and accomplished visitor who is also well versed in the history and lore of Dunnet Landing. In Arnow's *The Dollmaker,* Gertie Nevels uses "tools"

such as gardening, whittling, cooking, and caring for children in order to preserve community in the face of poverty, industrialism, and war. In *The Color Purple,* similarly, Celie's community is sustained by letter writing and sewing. And, in Toni Morrison's *Beloved,* giving birth and caring for children knit together communities torn apart by slavery.

Zagarell notes that narratives of community "represent the contrast between community life and the modern world directly through participant/observer narrators, and these narrators typically seek to diminish this distance in the process of giving voice to it" (503). In each of the texts examined here, the protagonist is in some sense set apart from the community, yet striving to become a part of it. In *The Country of the Pointed Firs,* Jewett's protagonist is clearly an outsider. Having become a "lover of Dunnet Landing" during a brief vacation cruise, she returns to develop that love affair into a "true friendship" by becoming a part of the community. In Arnow's *The Dollmaker,* Gertie is displaced from her deeply rooted life in Kentucky and must create a new community for herself in the rootless, transient, and fragmented environment of a wartime housing complex. In Walker's *The Color Purple,* Celie escapes ignorance, poverty, and sexual violence only when she is integrated into a loving community of women. In Toni Morrison's *Beloved,* Sethe's ties to community are threatened by slavery and the desperate choices that it forces her to make. Thus isolated, Sethe is threatened both physically and spiritually until she is reunited with community. In each of these texts, therefore, integration into community is represented not as a threat to the protagonist's autonomy, but as the fulfillment of her deepest needs and desires.

As many of these women writers have revised the novel form by placing community, rather than the individual, at the center of their texts, they have displaced the spiritual quest as well. The female characters in these texts seek spiritual truth not in solitary journeys, but in community. Through connection with community, these women transcend barriers—isolation, jealousy, prejudice, even death—which have traditionally separated them from one another. The community also offers healing in the midst of "ordinary" events which threaten women's lives: incest, violence, the deaths of children. In these works, salvation

is found not in solitude, but in what Carol Ochs has termed "the overcoming of separation" (3).

The whole of Jewett's *The Country of the Pointed Firs* may be read as a story about coming into community. Indeed, the narrator describes her return to Dunnet Landing in terms of relationship: referring to herself as a "lover of Dunnet Landing," she claims that getting to know the village is "like becoming acquainted with a single person. The process of falling in love at first sight is as final as it is swift in such a case, but the growth of true friendship may be a lifelong affair" (1–2). Upon her arrival in Dunnet Landing, the narrator rents a room from Mrs. Todd and quickly becomes her confidante and trusted apprentice. Mrs. Todd's work as an herbalist is a communal affair, and the narrator learns not only the healing properties of various herbs, but the pleasures of community with the women who come to the kitchen door, "combining the satisfactions of a friendly gossip with the medical opportunity" (8–9). At the center of this female community, Mrs. Todd functions as a "wise woman" whose remedies have both physical and spiritual healing properties: her prescriptions are "accompanied on their healing way as far as the gate," while directions are "muttered" or given in whispers with "an air of secrecy and importance" (4). Mrs. Todd's friendship with the narrator, too, is described in spiritual terms: "I do not know what herb of the night it was that used sometimes to send out a penetrating odor late in the evening, after the dew had fallen, and the moon was high, and the cool air came up from the sea. Then Mrs. Todd would feel that she must talk to somebody, and I was only too glad to listen" (7). Jewett thus constructs community and friendship as forms of enactment which create a relationship between the temporal world and the realm of the sacred and mysterious.

Ironically, the narrator of Jewett's text initially comes to Dunnet Landing seeking not community, but solitude. Indeed, in settling upon Mrs. Todd's house as an appropriate summer lodging place, she comments that its "one fault" is "its complete lack of seclusion" (3).

Resolving to choose discipline and solitude—the writing that she feels "bound" to do—over the pleasures of communal life, she rents out the abandoned schoolhouse as a place to write. Here she retreats each day in a "life pattern" which, Ann Romines observes, is "more commonly enacted by men" (54). Indeed, Jewett's narrator reports that she feels "most businesslike" returning home at sundown from her day's labors to the smell of Mrs. Todd's cooking (12).

As Romines points out, however, the secluded narrator also feels "bereft, locked away from the heart of village life and from herself" (54). From the schoolhouse window, she watches a funeral procession longingly, realizing that in withdrawing from it, as she tell herself, "[I] had now made myself and my friends remember that I did not really belong to Dunnet Landing" (Jewett 15). Her writing falters, her sentences failing "to catch these lovely summer cadences" (14–15). As Romines notes, it is the writer's very seclusion that diminishes the effectiveness of her writing: "If local weather were all she wanted to write about, the schoolhouse would be an ideal observation post. But 'summer cadences' are rhythmic patterns that come from human temporality and are often reinforced by ritual" (55–56). As *Pointed Firs* proceeds, the narrator seems to completely abandon the task she had brought with her to Dunnet Landing—her writing, with its enforced solitude—and to give herself wholeheartedly to the task which Mrs. Todd and village life place before her—entry into community.

Although narratives of community are generally rooted in one geographic space, in Jewett's text, a sense of community is often reinforced by journeying forth, the greatest pleasure of which is returning home again. These journeys contribute to what Elizabeth Ammons has termed the "weblike" structure of *Pointed Firs,* in which Mrs. Todd's home serves as the locus of community to which others are connected through friendship and care. These journeys also serve as pilgrimages in which the sacredness of community is reinforced. Jewett thus extends community beyond its physical boundaries to create a spiritual community based not on geographic proximity, but on love and empathy.

The narrator's journey to Green Island to visit Mrs. Todd's mother demonstrates the power of emotional ties to include even the dwellers

on this remote island in the spiritual community. Looking across the bay and seeing the island bathed in a ray of sunlight, the narrator sees it as "a sudden revelation of the world beyond this which some believe to be so near" (30). Green Island, home to the text's archetypal mother figure, Mrs. Blackett, is thus represented as a spiritual place, indeed as an earthly version of heaven. The communication between mother and daughter also takes place on a spiritual level. As the boat approaches Green Island, the narrator notes that even quicker than the welcoming wave of Mrs. Blackett's hand was the signal that "had made its way from the heart on shore to the heart on the sea" (35). Mrs. Blackett, like her daughter, extends her hospitality beyond the immediate community of family and friends to embrace a newcomer. "Tact is after all a kind of mindreading," the narrator comments, "and my hostess held the golden gift. Sympathy is of the mind as well as the heart, and Mrs. Blackett's world and mine were one from the moment we met" (46). The female community is thus defined not by familial or geographic ties, but by sympathy and hospitality.

Another important journey in Jewett's text occurs when the narrator, Mrs. Todd, and Mrs. Blackett travel "up country" for the Bowden family reunion. This journey is the culminating event of *Pointed Firs,* and also its most sustained celebration of community. As their carriage nears the old Bowden family home, the travelers join a great convergence of Bowdens arriving by both land and sea. Jewett elevates this much-anticipated event by describing it in distinctly mythic and spiritual terms:

> The sky, the sea, have watched poor humanity at its rites so long;
> we were no more a New England family celebrating its own exist-
> ence and simple progress; we carried the tokens and inheritance
> of all such households from which this had descended, and were
> only the latest of our line. We possessed the instincts of a far, for-
> gotten childhood. I found myself thinking that we ought to be
> carrying green branches and singing as we went. (100)

Even the food at this ceremonial gathering is celebratory and ritualistic. The most noted item on the banquet table is a gingerbread replica of the Bowden house. This is eaten, at the end of the feast, like a communion,

"not without seriousness, and as if it were a pledge and token of loyalty" (108). As is often the case in Jewett's text, with its reverence for domestic life, meals serve the sacred function of reinforcing community.

The Bowden family gathering serves not only as a celebration of community, but as a way of maintaining community in the face of threatening forces. Perhaps the greatest threat to community is death; as it does throughout Jewett's text, however, community here includes both the living and the dead. When Mrs. Blackett gives the narrator a tour of the Bowden home, she includes the family graveyard, thus sustaining spiritual connection even with those who have died. Significantly, the narrator notes that the graves are mostly those of women, the Bowden men having died on various quests at sea, in the West, or at war; even in death, Jewett's community is a female one. The reunion also heals rifts between those long separated by anger. "Such a day as this has transfiguring powers," Jewett writes, "and easily makes friends of those who have been cold-hearted" (96). Watching the fond good-byes at the end of the day, the narrator observes, "I fancied that old feuds had been overlooked, and the old saying that blood is thicker than water had again proved itself true. . . . Clannishness is an instinct of the heart,—it is more than a birthright, or a custom; and lesser rights were forgotten in the claim to a common inheritance" (110). Community here relies not on blood ties, however, but on spiritual ties of love, dependence, and care. The narrator, who had felt upon her arrival that she "did not really belong to Dunnet Landing" (15), now easily includes herself in the community, speaking of the Bowden family not as "they," but as "we." Departing the celebration, she says forthrightly, "I came near to feeling like a true Bowden" (110). The culmination of Jewett's text is thus not only the gathering of the community, but the full integration of the narrator into that community.

As with all journeys in Jewett's text, this one, too, is circular. Although Mrs. Todd and her company are among the last to leave the reunion, they head home purposefully, their thoughts already turning to unfinished tasks left behind. "Those that enjoyed it best'll want to get right home so's to think it over," Mrs. Todd declares (111). To fully appreciate the pleasures of the day, one must incorporate them into memory and story. The journey to the Bowden family reunion is nei-

ther linear nor solitary, but a circular journey which both reinforces and celebrates community.

Several of Jewett's stories which were not included in the original *Pointed Firs* collection also focus on the creation and maintenance of community. In "The Queen's Twin," Mrs. Todd and the unnamed narrator of *Pointed Firs* visit Abby Martin, an old woman who lives in a "dreadful out o' the way place" inland from Dunnet Landing. Isolated from friends and family by both geography and her odd, imaginative nature, Abby Martin creates a community for herself by inventing an imaginary kinship with Queen Victoria—a friendship which, as Mrs. Todd says, "has buoyed her over many a shoal place in life" (200). Abby Martin's connection to the Queen has a sacred quality. In the kitchen, a picture of Her Majesty, graced by a vase of flowers, forms a "shrine" (206), while her best room, the walls of which are covered with pictures of the Queen, is kept "shut up sacred as a meetin'-house" (200). Mrs. Martin turns to the Queen for comfort and guidance as others turn to God in prayer: "I've often walked out into the woods alone and told her what my troubles was, and it always seemed as if she told me 'twas all right, an' we must have patience. . . . she's been the great lesson I've had to live by" (206–7). Through Abby's devotion, the Queen's book about the Highlands becomes a sacred text which she saves to read only on Sundays. Much as the narrator overcomes isolation by allowing herself to be drawn into the Dunnet Landing community, Abby Martin transcends her own loneliness through this imaginary friendship.

In Jewett's text, visiting is an important, even solemn ritual through which community is preserved. Mrs. Todd's visit to Abby Martin serves the dual function of transcending Mrs. Martin's isolation and teaching the narrator the art of maintaining community. Visiting, to Mrs. Todd, is a sacred vocation, and she presides over this visit with great seriousness and a measure of anxiety. Taking care that her friend not be laughed at, Mrs. Todd tests the narrator's receptivity to Abby's story and warns that not all will be included in the sacred community: "I do hope Mis' Martin'll ask you into her best room where she keeps all the Queen's pictures . . . 'tain't everybody she deems worthy to visit 'em, I can tell you!" (200). Mrs. Todd thus serves as both a protector of her friend Abby Martin and a mentor to her younger friend, the narrator. As Mrs. Todd

and the narrator begin their journey home, they agree, "[I]t ain't as if we left her all alone!" (211). Indeed, this visit has been about transcending loneliness and sustaining community, both the physical community of friends and the spiritual community of the imagination.

While Jewett's Dunnet Landing is a protected community, sheltered by physical isolation from external forces that would threaten it, Harriette Arnow's *The Dollmaker* depicts a community under siege. *The Dollmaker* recalls the great migration of Americans from the rural South to northern industrial cities during World War II, when men like Arnow's Clovis Nevels gave up their lives as farmers, coal miners, and merchants and moved their families north to join the "war effort." If it were told from Clovis's point of view, Arnow's story would parallel many such quest stories in the American canon. Clovis Nevels, like the American Adam, flees the restrictions imposed by family and community—in this case, the chance to work for steady wages in a factory rather than farm another man's land. Told from Gertie Nevels' perspective, however, *The Dollmaker* reveals another side of the war years: the experience of women and children uprooted from their homes and of a communal life threatened by poverty, prejudice, and violence. Arnow's novel emphasizes not the individual adventure often associated with war as it is depicted in the novel, but the destructive effect of war on community.

The Dollmaker's depiction of a rural Kentucky community during wartime reflects the devastating toll of war on communal life. Drafted into military service or lured by the promise of good wages, men have deserted the settlement, leaving women and children behind to worry and wait. To Gertie Nevels, the road which had once seemed "so fine and new, tying their settlement to the outside world, seemed now only a thing that took the people away" (51). In the absence of the men, Gertie assumes the role of holding this fragile community together. A large, powerful woman, unsuited to women's work or dress, she has always seemed an anomaly in her community. With the men gone,

however, Gertie easily assumes their chores, lifting heavy loads and comforting women who are frightened by staying alone.

Gertie finds the source of her spiritual strength in her connection to the community and to the land. Her religious vision is a deeply personal one that is closely connected with the earth. "A body don't have to go to Jesus," she tells her youngest child, Cassie. "He's right down here on earth all th time" (76). Gertie's greatest dream is of buying her own farm, the Tipton Place—"a little piece a heaven right here on earth" (77). When Clovis leaves for Detroit and Gertie's beloved brother, Henley, dies in the war, leaving her enough money to buy the farm, she describes his sacrificial death in biblical language: "It was as if the war and Henley's death had been a plan to help set her and her children free so that she might live and be beholden to no man, not even to Clovis" (139). Gertie is also an artist, a woodcarver, and her artistic and religious visions merge in her perpetually unfinished carving of a human figure. As she draws nearer to her dream of owning the Tipton Place, the emerging face in the wood seems to be that of Christ. When she inherits Henley's money and is secure in knowing that the Tipton Place will be hers, she sees in the wood "the laughing Christ, a Christ for Henley" (81).

Although Gertie's personal religious vision reinforces a vision of community as a saving force, the more narrow and conventional religious vision of her neighbors transforms the community into a source of oppression. Gertie's religious vision is heretical in the eyes of her community, and it is the hill community's fundamentalist religion that prevents her from buying the land. "Oh, Lord, oh, Lord, she's turned her own children against their father," her mother cries. "She's never taught them the Bible where it says, 'Leave all else an cleave to thy husband.' She's never read to them th words writ by Paul, 'Wives, be in subjection unto your husbands, as unto th Lord'" (141). Gertie's mother thus uses the Bible to urge her toward submissiveness—following Clovis to Detroit. In buying the land, however, Gertie pictures herself as the godly woman from Proverbs: "She considereth a field and buyeth it; with the fruit of her own hands she planteth a vineyard" (112). Gertie's "foundation," she asserts, is "not God but what God had promised Moses—

land" (127–28). Ultimately bowing to the religious strictures voiced by her mother, Gertie concedes: "It's what a woman's got to do, I recken. . . . Foller—take on a man's kind a life like Ruth" (358). As Gertie moves with her children to Detroit, exchanging her deeply rooted life in Kentucky for a rootless "man's kind a life," her religious vision fades.

When she and her family move to industrial Detroit, Gertie's dream of community initially seems impossible: Detroit seems to her "a world not meant for people" (168). Here, all signs of nature are obscured: the sky is the perpetual even gray of industrial smoke, and the hills are not hills at all, but great slag piles. Far from the farming community where she had been one to whom others turned for help and strength, Gertie is made to feel incompetent and helpless. While her children expect from her "the warmth and food she had always given," she is stymied by mysterious kitchen appliances, poor quality and rationed food, and the shame of buying on credit (174). Increasingly perceiving herself as a traitor to her children, Gertie finds that her vision of Christ in the wood fades, replaced by the face of Judas: "Not Judas with his mouth all drooly, his hand held out fer th silver," she explains, "but Judas given th thirty pieces away. I figger . . . they's many a one does meanness fer money—like Judas. . . . But they's not many like him gives th money away an feels sorry onct they've got it" (23). Gertie's sympathy for this repentant Judas reflects her guilt about betraying her own values.

In Detroit, Gertie learns that prejudice is another by-product of the war which threatens community. The factories have attracted families from all over the country with the promise of jobs, and industrial Detroit is a clashing, volatile mixture of racial, ethnic, and religious backgrounds. Gertie and her family are labeled "hillbillies," the word spat at them "as if . . . a vile thing to be spewed out quickly" (156). Here people are held together not by community, but by killing—the manufacture of weapons to fuel the fighting overseas. In Detroit, as in Kentucky, traditional religion breeds division rather than community. Gertie's Catholic neighbors, the Dalys, use their religion as a weapon to bludgeon others who live in the wartime housing project. When a missionary comes to her door spreading the gospel, Mrs. Daly throws a bucket of mop water on her and assails her with curses, "all mixed in

with prayer-sounding pieces of talk to the Virgin, Father Moneyhan, and various saints" (224).

The intolerance and prejudice of the alley ultimately lead to the loss of two of Gertie's children. Reuben and Cassie, the children who are most like Gertie in their artistic sensitivity and love for the land, are ill-suited for this harsh environment. Blaming Gertie for the loss of their land back home, Reuben begins to look at her with eyes "filled with the contempt of the strong for the weak" (143). Ostracized at school for his failure to "adjust," Reuben runs away, returning to Kentucky to live with his grandparents. Plagued with guilt, Gertie searches through her Bible for guidance and comfort, but returns always to the description of Judas: "'I have sinned in that I betrayed innocent blood.' . . . And he cast down the pieces of silver . . . and he went away and hanged himself" (361).

Cassie, like Reuben, never learns to "adjust" to the new life in Detroit. Her one joy is her continued friendship with her imaginary friend, Callie Lou, who plays with her in the alley. When Cassie is mocked by the other children, Gertie initially defends her youngest child's independent spirit. Pressured by Clovis and by her neighbors to make Cassie conform, however, she gives in, telling Cassie, "There ain't no Callie Lou": "Reuben was lost to her, the alley had the others, Henley was dead, his money gone, the land lost. . . . Giving up, giving up; now Cassie had to do it" (379). When Cassie takes refuge in the railroad yard, where she can play with Callie Lou far from her mother's reproachful eye, she is run over by an approaching train as Gertie struggles desperately to reach her in time. When Cassie dies in the hospital, an unbelieving Gertie insists that the money she has saved through the years to buy her land will get her child out of the cold, windowless place. She lays it in Clovis's "startled, trembling hands: the old bills, the ones in balls, in tiny squares, the bill with the pinpricks through Lincoln's eyes, the dominecker-hen money . . ." (411). Gertie becomes the picture of the repentant Judas she imagined in the wood: she tries to give the money back, to undo the death in which she is complicit, but she is too late.

In the midst of Detroit's destroying intolerance and prejudice, the women of the alley nonetheless demonstrate an ethic of care which transcends a dominant culture marked by bigotry and violence. In her

despair after Cassie's death, Gertie turns first for comfort to her wood carving: "All her life she'd needed time for this, and now she had time only, years and years of it to get through" (415). Increasingly, however, the figure in the wood reflects neither Judas's guilt nor Christ's forgiveness, but only Gertie's own exhaustion and loss: "The arms grew tonight, not fully, but enough she knew the hands would not be reaching out, but holding—holding lightly a thing they could not keep" (444). Her neighbors, however, sharing with Gertie the grief of a mother for a lost child, appear at her door to offer meals and comfort and to care for her children. Gradually, Gertie begins to learn "the bigness of the alley, the kindness; big enough and more it would have been for Callie Lou—and maybe Reuben, too, for the alley and the people in it were bigger than Detroit" (436).

Although divided by language, ethnicity, and prejudice, the women are also united by the need to feed their families and care for their children in this cruel urban environment. When word of the atomic bomb dropped on Hiroshima reaches the alley, the bigoted Mrs. Daly forgets her hatred of "them Japs" in her sympathy for their neighbor, Mrs. Saito, whom she hears weeping at night through the thin walls of their apartment: "Why them Japs lives something like this . . . all crowded up tugedder inu towns; little cardboard houses kinda like what we've got; and maybe lotsa—you know—kids" (496). The women's daily activities—caring for one another's children, carrying food to sick or troubled neighbors, tending straggly flower gardens in an effort to transcend the alley's ugliness—contrast with the men's dirty, dangerous work in the war factories and the increasing violence of union activities. When Clovis uses Gertie's whittling knife to kill a man in a union conflict, her efforts to preserve family and community are further juxtaposed with the threat of violence. Even when the war is over, the community weighs this victory against the loss of jobs that the war ensured: "Gertie could hear no rejoicing, no lifting of the heart that all the planned killing and wounding of men were finished. Rather it was as if the people had lived on blood, and now that the bleeding was ended, they were worried about their future food" (495).

Gertie's commitment to feeding her family ultimately decides both the fate and the identity of her faceless carving. As the Nevels'

savings dwindle, Gertie takes the cherry wood figure to the scrap-wood lot to have it sawed into boards for whittling figures she can sell. Seeing the face still partially submerged in the beautiful wood, the scrap-wood man cannot bring himself to cut it; it is Gertie who swings the ax into the bent head. The man gazes at the place where the face should have been: "Christ yu meant it tu be—butcha couldn't find no face fu him." Gertie shakes her head:

> "No. They was so many would ha done; they's millions an millions a faces plenty fine enough—fer him."
>
> She pondered, then slowly lifted her glance from the block of wood, and wonder seemed mixed in with the pain. "Why, some a my neighbors down there in th alley—they would ha done." (599)

As Gertie sacrifices the cherry wood figure, Arnow seems to suggest that the image hidden in the wood is, after all, that of Christ. The splitting of the figure is a symbolic crucifixion, the wood giving way with a "crying, rendering sound" suggesting a voluntary giving up of wholeness and of life. It is only in sacrificing for the sake of her family, however, that Gertie finds a face for this Christ; neither hidden within her imagination nor lost with the land, it has been with her all along, living in the alley in the faces of her neighbors. The true face, the true presence of Gertie's Christ—and the true expression of her artistic vision—is to be found not in isolated, solitary pursuit, but in the familial and communal life of the alley.

"I want to thank everybody in this book for coming," Alice Walker writes at the conclusion of her 1982 novel, *The Color Purple* (253). This postscript, signed "A. W., author and medium," places the issue of spiritual community at the center of the novel. As a "medium," Walker summons her characters, all members of a spiritual community, to tell their individual and collective stories. Although hers is a colorful and ultimately joyful gathering, however, the spiritual community in Walker's novel, as in many twentieth-century narratives of community,

is under siege. Like Arnow's *The Dollmaker, The Color Purple* is the story of a spiritual community which transcends the forces that threaten to destroy it.

In the midst of the violent and fragmented lives of her female characters, Walker weaves a tenuous web of care among women. Her protagonist, Celie, is a pregnant teenage victim of paternal incest, so ignorant and uncared for that she barely knows what has happened to her: "When I start to hurt and then my stomach start moving and then that little baby come out my pussy chewing on it fist you could have knock me over with a feather," Celie writes in wonderment (12). Although her own life is entirely unprotected, however, Celie's greatest concern is to protect her younger sister, Nettie. When Celie notices her father eyeing Nettie, she is careful to "git in his light" (15) and even asks him, "[T]ake me instead of Nettie" (17). In return, Nettie tries to protect Celie in the only way she can: by teaching her to read and write. Celie's rudimentary literacy makes possible her letters to God, which serve as her lifeline through much of the novel. The sisters thus construct a fragile community that ties them to each other, enacting the spiritual in the midst of violence and despair.

Much as the community in Arnow's *The Dollmaker* serves to transcend the divisiveness of prejudice, Walker's spiritual community transcends conventional barriers and prejudices between women. When her husband brings home his lover, Celie immediately senses her own connection with this woman, seeing beneath Shug Avery's beauty to the sadness in her eyes. Rather than responding to Shug as a competitor, Celie nurses Shug through an illness, her loving care connecting both women to a lost tradition of being cared for by women: "I work on her like she a doll or like she Olivia—or like she mama," Celie writes. "First she say, hurry up and git finish. Then she melt down a little and lean back gainst my knees. That feel just right, she say. That feel like mama used to do. Or maybe not mama. Maybe grandma" (57). The loving attachment between Celie and Shug thus fills a void left by the absent mothers in each of their lives.

With Celie at its center, the protective web woven by the community of women gradually extends to the novel's other female characters as well. The initially self-centered Shug is transformed into Celie's

protector, shielding her from Albert and ultimately taking her away from his house. Sofia and Mary Agnes, like Celie and Shug, are initially sexual rivals. When Sofia is imprisoned for impudence toward the mayor's wife, however, Mary Agnes sacrifices herself by having sex with the prison warden in order to secure Sofia's release. Even in Africa, where Celie's children, Olivia and Adam, are being raised by Nettie, Olivia teaches her native friend Tashi to read just as Nettie had once taught Celie to read. When Celie receives word that Nettie and the children have died on their voyage home from Africa, she asks, "How can you be dead if I still feel you?" (229). Indeed, Celie's spiritual connection to Nettie proves prophetic; her sister is not dead, and the two are ultimately reunited at Celie's home. The protective female community thus transcends both geographical and psychological distances, connecting all of the women in the text in a life-sustaining web of sacrifice and friendship.

Celie's quest for community is also a quest for spiritual truth—for a connection to God that is both authentic and life sustaining. The novel is structured by letters to God in which Celie tries to overcome her isolation as she puzzles over the events of her life. Celie's efforts to build community with other women are also cast in spiritual terms. When she grows jealous of Sofia's self-assertion and powerful voice and advises her husband to beat her in order to gain control of her, Celie is made sleepless by the guilty knowledge that she has "sin against Sofia spirit" (45). When she makes her peace with Sofia, healing the rift between them, she "sleeps like a baby" again (47). Celie describes bathing Shug as "praying" (53) and sleeping with her as "heaven" (110). When she gains the courage to leave her husband, she tells him that she is ready to "enter into the Creation" (181). To leave behind isolation and enter into community is thus depicted as an enactment of spirituality, connecting individuals to a source of meaning and power.

Although Walker clearly portrays Celie's entry into community as spiritual, she, like Jewett, Arnow, and Morrison, rejects conventional religion as a source of spiritual guidance and truth. Initially, Celie speaks in the voice of conventional Christian piety: "Well, sometime Mr. ——— git on me pretty hard," she tells Sofia. "I have to talk to Old Maker. But he my husband. I shrug my shoulders. This life soon be over, I say.

Heaven last all ways." "You ought to bash Mr. —— head open," Sofia responds promptly. "Think bout heaven later" (47). Although Sofia's response makes Celie laugh, she is unable at that point to accept it as a serious prescription for her life. It is only Celie's outrage when she learns that Mr. —— has violated her fragile community with Nettie by hiding her letters over the years that finally causes her to rail against the image of God as "old white man":

> [H]e give me a lynched daddy, a crazy mama, a lowdown dog of
> a step pa and a sister I probably won't ever see again . . . the God
> I been praying and writing to is a man. And act just like all the
> other mens I know. Trifling, forgitful and lowdown. (175)

While Celie seems on the verge of rejecting God as a source of truth, however, Shug shows her that it is not God, but her image of God, that is limited. Shug introduces Celie to the idea that God is to be found not in church, but inside herself and in all of creation:

> My first step from the old white man was trees. Then air. Then
> birds. Then other people. But one day when I was sitting quiet
> and feeling like a motherless child, which I was, it come to me:
> that feeling of being part of everything, not separate at all. I knew
> that if I cut a tree, my arm would bleed. (178)

For Shug, spirituality is thus enacted through connection to the natural world and to other people. Although this sounds like "blasphemy" to Celie, her spiritual vision eventually begins to shift. She now addresses her letters not to God, but to Nettie, thus substituting female community for the "old white man" as the source of spiritual truth. Signifying the spiritual nature of her connection with Nettie, Celie signs her letters "Amen."

As the spiritual community binds women together, it also helps them to gain their voices. Walker's *The Color Purple* begins with enforced silence: *"You better not never tell nobody but God,"* Mr. —— threatens Celie. *"It'd kill your mammy"* (11). Throughout her spiritual evolution, however, Celie learns that truth-telling does not kill, but saves. Celie is able to "enter into the Creation" when she tells the truth of her life not only to God, but to a loving and supportive community

of friends. Harpo's timid wife, too, learns from Celie and her other women friends to speak for herself. When she gains the courage to stand up to Harpo and to sing in public, she celebrates her newly found voice by casting off her constraining, diminutive nickname—Squeak—and insisting that Harpo call her Mary Agnes. Sofia, who initially provides one of the strongest female voices in the text, temporarily loses her power when she is beaten and imprisoned by white oppressors. Weak and sick, she begins to regain her voice when she sees Celie's courage in standing up to Mr. ————: "It like a voice speaking from the grave," Celie writes (182). Indeed, all of Walker's female characters are, in a sense, speaking from the grave: from living deaths imposed on them in the form of violence, sexual exploitation, and racism. Isolated as individuals, however, they gain a collective strength when united by their common experiences.

While women are the creators of spiritual community in Walker's text, as in Jewett's and Arnow's, this is a community in which distinctions and barriers between women and men are ultimately dissolved. When Shug leaves both Albert and Celie, Albert confesses that he loved Shug because she "act more manly than most men. I mean she upright, honest. Speak her mind and the devil take the hindmost, he say. . . . She bound to live her life and be herself no matter what" (236). When Celie points out to him that both Shug and Sofia are better exemplars of these "manly" qualities than either himself or Harpo, Albert is forced to concede that these qualities are no less womanly than manly. Celie's manufacture of unisex "folkspants" serves as the text's central symbol of this all-inclusive community. Although Albert initially protests, "Men and women not suppose to wear the same thing. . . . Men spose to wear the pants," Celie insists that the special quality of her pants lies in the fact that "Anybody can wear them" (238). When Albert joins Celie in sitting and sewing pants on her front porch, he is fully integrated into the community—no longer the evil Mr. ————, but simply Albert. Harpo, too, who had once rejected Sofia because he could not control her, is reunited with her and welcomed into the community when he simply allows Sofia to do whatever makes her happy. The "family reunion" which concludes Walker's text thus includes women and men, Africans

and Americans, former enemies and spurned lovers. Celie's final letter is addressed neither to a white male God nor to Nettie, but to this all-inclusive spiritual community: "Dear God. Dear stars, dear trees, dear sky, dear peoples. Dear Everything. Dear God" (249).

Like both Arnow's *The Dollmaker* and Walker's *The Color Purple,* Toni Morrison's *Beloved* is a story of community lost and then restored. Set in Cincinnati during the Civil War, Morrison's narrative chronicles the life of Sethe, a woman who has come north to live with her children and mother-in-law, Baby Suggs, after a harrowing escape from slavery. The house at 124 Bluestone Road has become a way station for the dispersed black community: "Some of them were running from family that could not support them, some to family; some were running from dead crops, dead kin, life threats, and took-over land . . . configurations and blends of families of women and children, while elsewhere, solitary, hunted and hunting for, were men, men, men" (52). Within this fragmented community, Baby Suggs's house is a place of healing and respite: "[N]ot one but two pots simmered on the stove . . . the lamp burned all night long. Strangers rested there while children tried on their shoes. Messages were left there, for whoever needed them was sure to stop in one day soon" (87). Having lived all of her life as a slave, Sethe enters into this free black community hungrily.

Sethe's integration into community is abruptly halted when her former owner, armed and accompanied by slave catchers, arrives to claim her and her children. In a desperate attempt to save her children from being recaptured into slavery, Sethe kills her infant daughter. Her action, although committed as a desperate act of love, ostracizes her from the community: "The twenty-eight days of having women friends, a mother-in-law, and all her children together; of being part of a neighborhood; of, in fact, having neighbors at all to call her own— all that was long gone and would never come back. . . . Those twenty-eight happy days were followed by eighteen years of disapproval and a solitary life" (173). Even more unforgivable than Sethe's crime is her self-isolation. Ella, a leader among the women of the community,

"understood Sethe's rage . . . but not her reaction to it, which Ella though was prideful, misdirected. . . . When she got out of jail and made no gesture toward anybody, and lived as though she were alone, Ella junked her and wouldn't give her the time of day" (256). This isolation from community leaves Sethe vulnerable when she is threatened by the ghost of her murdered daughter. Only when the community is restored is she protected from the evil that haunts her.

While *Beloved* suggests the power of community to save and to heal, Morrison also illustrates the devastating consequences of a community's failure to perform this role. As in both *The Dollmaker* and *The Color Purple,* the community in *Beloved* must overcome the forces that threaten to destroy it. In Morrison's text, this includes not only the external threat of slavery, but the community's own pettiness and jealousy toward its members. Morrison attributes Sethe's killing of her infant daughter, in part, to her neighbors' failure to warn her of the slave catchers' approach. On the day following Baby Suggs's party to celebrate Sethe's arrival, her friends are consumed with jealousy:

> Too much, they thought. Where does she get it all, Baby Suggs, holy?. . . Loaves and fishes were His powers—they did not belong to an ex-slave. . . . They swallowed baking soda, the morning after, to calm the stomach violence caused by the bounty, the reckless generosity on display at 124. (137)

Later, Stamp Paid realizes the community's culpability in the disaster that befell Baby Suggs's family later that day:

> Nobody warned them, and he's always believed it wasn't the exhaustion from a long day's gorging that dulled them, but some other thing—like, well, like meanness—that let them stand aside, or not pay attention, or tell themselves somebody else was probably bearing the news already to the house on Bluestone Road. . . . Maybe they just wanted to know if Baby really was special, blessed in some way they were not. (157)

Community is thus not inherently sacred in Morrison's text; rather, when community functions to heal and protect its members, it enacts the sacred and gains the power to drive out evil.

In Morrison's novel, as in the works of Jewett and Arnow,

community has a spiritual function which transcends the authority of conventional religion. The black community surrounding 124 Bluestone Road is presided over by Sethe's mother-in-law, an "unchurched preacher . . . who visited pulpits and opened her great heart to those who could use it. . . . Uncalled, unrobed, unanointed, she let her great heart beat in their presence" (87). Rejecting the divisions of conventional religion, Baby Suggs welcomes "AME's and Baptists, Holinesses and Sanctifieds, the Church of the Redeemer and the Redeemed" (87). Although she clearly functions as a preacher in the community, she accepts "no title of honor before her name, but [allows] a small caress after it"; she is known in the community as "Baby Suggs, holy" (87). Baby Suggs's ministry is thus depicted as nonhierarchical and communal —a ministry not of authority, but of mutuality.

As Kimberly Rae Connor writes in *Conversions and Visions in the Writings of African-American Women,* the conversion experience of African Americans is "founded on a religion of spiritual resistance where women and men ask not for God's forgiveness but for God's recognition" (13). "There was little tolerance for a doctrine of original sin because to blacks sin meant wrongdoing," Connor continues, "and they did not earn their suffering by wrongdoing" (21). Baby Suggs, indeed, finds the traditional gospel message of sin and redemption inappropriate for survivors of slavery, as Morrison writes:

> She did not tell them to clean up their lives or to go and sin no more. She did not tell them that they were the blessed of the earth, its inheriting meek or its glorybound poor. She told them that the only grace they could have was the grace they could imagine. That if they could not see it, they would not have it. (88)

In this community, grace and salvation come not from a distant God, but from the strength of the individual and the community.

As in *The Dollmaker* and *The Bluest Eye,* however, the community in Morrison's *Beloved* is potentially transformative, but also vulnerable. Even Baby Suggs's healing spirituality cannot overcome the power of slavery to destroy community. When the community shuns Sethe and her family, Baby Suggs withdraws to her bed to die:

"Those white things have taken all that I had or dreamed . . . and broke my heartstrings too. There is no bad luck in the world but whitefolks." 124 shut down and put up with the venom of its ghost. No more lamp all night long, or neighbors dropping by. No low conversations after supper. No watched barefoot children playing in the shoes of strangers. . . . There was no grace—imaginary or real—and no sunlit dance in a Clearing could change that. Her faith, her love, her imagination and her great big old heart began to collapse twenty-eight days after her daughter-in-law arrived. (89)

When the ghost of her sacrificed daughter, Beloved, begins haunting the house—shaking furniture, overturning dishes, and shattering mirrors —Sethe's sons flee, leaving Sethe and her younger daughter, Denver, alone and isolated in the house for the next eighteen years.

While the ghost of Beloved is vengeful and, ultimately, dangerous, she is also, as her name indicates, beloved—brought into being by Sethe and Denver's intense longing for her. It is Denver who first recognizes the ghost as her "sister" (13); and when Sethe's lover, Paul D., temporarily chases the ghost away with "a table and a loud male voice" (37), Denver resents him as "the man who had gotten rid of the only other company she had" (19). When Beloved appears physically, Denver forms a jealous, possessive relationship with her: "Nothing was out there that this sister-girl did not provide in abundance: a racing heart, dreaminess, society, danger, beauty" (76). When she tells Beloved about her own birth during her mother's journey north, she uses the story "to construct out of the strings she had heard all her life a net to hold Beloved" (76). Beloved thus comes into being out of the longing for lost community— Sethe's longing for her daughter and Denver's need for her sister.

Sethe's intensely dependent relationship with Beloved, too, indicates that her passion for her lost child has helped to bring her back. Although she initially acts as a mother to Beloved, their roles are gradually reversed and Sethe becomes a chastened child: "The bigger Beloved got, the smaller Sethe became; the brighter Beloved's eyes, the more those eyes that used never to look away became slits of sleeplessness. . . . Beloved ate up her life, took it, swelled up with it, grew taller on it. And the older woman yielded it up without a murmur" (250). While

Sethe grows increasingly helpless, Denver gradually comes to understand the nature of this relationship: "Sethe was trying to make up for the handsaw; Beloved was making her pay for it . . . she knew Sethe's greatest fear was the same one Denver had in the beginning—that Beloved might leave" (251). Sethe's danger, therefore, stems from her desperation to recover the community she has lost.

In order to rescue her mother from the now-evil presence of Beloved, Denver turns to the saving power of community: "She would have to leave the yard; step off the edge of the world, leave the two behind and go ask somebody for help" (243). It is this plea for help that reunites her family with the community. Ella, who had scorned Sethe not only because of her crime, but because of her self-imposed isolation, admits that Denver "appeared to have some sense after all. At least she had stepped out the door, asked for the help she needed and wanted work" (256). Soon, a steady stream of food offerings begins to arrive at 124 Bluestone Road, and Denver ventures off her porch again, to the kitchen doors of women, each time a bowl or basket must be returned. Morrison depicts this connection with community as transformative, enacting Denver's rite of passage into womanhood: "The trail she followed to get to that sweet thorny place was made up of paper scraps containing the handwritten names of others" (248). Denver's journey, unlike that of the canonical hero, is a journey into community.

Denver's arrival in their lives triggers the women's memories of the community once found at 124 Bluestone Road; they remember stopping there for advice or information, or to dance in the clearing at one of Baby Suggs's worship services. Denver's admission of need and the women's response to that need brings about the restoration of community:

> Maybe they were sorry for her. Or for Sethe. Maybe they were
> sorry for the years of their own disdain. Maybe they were simply
> nice people who could hold meanness toward each other for just
> so long and when trouble rode bareback among them, quickly,
> easily they did what they could to trip him up. (249)

It is this community of women that is ultimately responsible for driving off the evil at 124 Bluestone Road and restoring Sethe's family to a place in the community. The women who march to the house are

united not by shared belief, nor even by a firm understanding of what they are about to do:

> Some brought what they could and what they believed would work. Stuffed in apron pockets, strung around their necks, lying in the space between their breasts. Others brought Christian faith—as shield and sword. Most brought a little of both. They had no idea what they would do once they got there. They just started out, walked down Bluestone Road and came together at the agreed-upon time. (257)

Rather, they are united by the power of community, responding to the one among them who, because of her isolation, is in danger. It is before this powerful female community that Beloved disappears out of Sethe's life.

In Morrison's text, as in *The Country of the Pointed Firs, The Dollmaker,* and *The Color Purple,* it is women who create and sustain community. When Beloved enters their home, Sethe's two sons "[grow] furious at the company of the women in the house" (104); when the baby ghost's presence grows too insistent, they flee. Paul D., too, reacts violently to the ghost's presence. Denver suspects Paul D. of taking the baby ghost's place "for himself" (104), and even Sethe senses that he "resented the children she had . . . Sharing her with the girls. Hearing the three of them laughing at something he wasn't in on. The code they used among themselves that he could not break. . . . They were a family somehow and he was not the head of it" (132). What ultimately separates Paul D. from the community of women, however, is his failure to understand Sethe's actions on the day that the slave catchers came for her and her children. Paul D. casts Sethe's act of mother-love as barbarous, telling her that she has "two feet . . . not four" as he flees the house (165). While Paul D. believes that he has made the house "safe" by violently chasing off the baby ghost, he is chilled by Sethe's definition of safety: "This here Sethe talked about safety with a handsaw" (164).

Although women create this community, however, Morrison, like Alice Walker, ultimately includes both women and men in the community. After the women have driven off Beloved and Sethe has retreated to Baby Suggs's room to die of her pain and loss, Paul D.

returns to care for her. Rather than counting her feet in judgment, as he had when he left, Paul D. redeems himself by taking Baby Suggs's role of caretaker, rubbing Sethe's feet and bathing her as Baby Suggs had when Sethe first arrived at her home. In Paul D., Sethe finds a man to whom women can "tell . . . things they only told each other" (272). Theologians Kelly Brown Douglas and Cheryl J. Sanders attribute the inclusive spirit of black feminist theology to the influence of Alice Walker's term "womanism," defined in the epigraph to her essay collection *In Search of Our Mothers' Gardens*. Walker defines a womanist, in part, as one "[c]ommitted to survival and wholeness of entire people, male *and* female" (xi). This inclusive spirit infuses contemporary fiction by African-American women writers; Paul D., like Albert in Walker's *The Color Purple,* is thus integrated into the community that the women have created.

Each of the texts discussed here reinforces Zagarell's identification of "narrative of community" as a genre which challenges the novel form. These works focus not on a single protagonist, but on the struggle of a community to maintain itself, often in the face of threatening forces. Each of these communities also serves a spiritual function, challenging the dominant cultural myth of individual quest as the source of spirituality. The female characters in these works are transformed not by the journey from community, but by the preserving of community.

Chapter IV

Telling
Sacred Stories

words flash from you I never thought of
we are translations into different dialects

of a text still being written
in the original

—Adrienne Rich

An academic interest in storytelling is not the exclusive province of literary scholars. Psychologists, sociologists, historians, anthropologists, and other academic researchers have long employed the interview and the personal narrative as research techniques. Traditionally, social scientists have treated stories from their subjects as "reports from the front lines," George Rosenwald and Richard Ochberg write in *Storied Lives: the Cultural Politics of Self-Understanding:* "[I]t was the events themselves, not the stories told about them, that were intended to command our attention. . . . Like photographs, these histories were intended to be read as objective descriptions, different only in format from the descriptions of social science" (2).

During the past two decades, however, the treatment of stories as empirical reflections of human experience has changed. Researchers in many disciplines now agree that stories are not mirrors held up to life, but constructs which both shape and are shaped by life experience. "[P]ersonal accounts are now read with an eye not just to the scenes they describe, but to the process, product, and consequences of reportage

itself," Rosenwald and Ochberg write (2). This emphasis on process and context has been influential in literary studies as well, particularly in the area of reader–response criticism, which assumes a relationship between reader and text out of which new meanings continually arise. In *Folk Roots and Mythic Wings in Sarah Orne Jewett and Toni Morrison: The Cultural Foundations of Narrative,* literary critic Marilyn Sanders Mobley concurs: "Narrative," she writes, "has the dual role . . . of being something told and of being a way of knowing" (175).

Implicit in the belief that stories are constructs of individual and communal experience is the understanding that stories are not only informed, but also limited, by the teller's frame of reference. Stories are not universal, but are necessarily limited by culture, gender, age, and other factors which shape the teller's life experience. "Events 'make sense' as they are placed in the correct story form," Mary Gergen writes in "Life Stories: Pieces of a Dream." "If certain story forms are absent, events cannot take on the same meaning" (132). Many stories in canonical American fiction therefore take place within the "story forms" provided by these larger cultural myths.

One of the most prevalent story forms within the American literary canon is the story of spiritual quest. This literary myth reflects the larger cultural myth of America as a land of self-made men, single-handedly hewing their individual ways through a wilderness both literal and symbolic. "Americans cling to the myth of individualism as though it were the only way to live," Rollo May writes in *The Cry for Myth.* "We feel as Americans that every person must be ready to stand alone, each of us following the powerful myth of the lone cabin on the prairie" (108). In both autobiography and fiction, many American writers have shaped their narratives to reflect this cultural myth. Stories of cowboys and space travelers, escaped slaves and seafarers cast the wilderness quest as the source of spiritual truth. Further, this quest is most often a solitary one; home and community serve as encumbrances which must be cast off in order for the hero to attain both physical and spiritual goals.

As the present study has shown, however, the experience that this myth reflects is far from universal. Rather, it is tied to theological and psychological belief systems which present male experience as norma-

tive and female experience as an aberration from that norm. The stories that American women writers tell—and that their female characters tell one another—often serve quite different functions. In the texts examined here, most of the female characters who tell stories have neither the autonomy nor the inclination to flee community in search of spiritual truths. For these characters, rather, spirituality lies not in fleeing community, but in preserving it. In Sarah Orne Jewett's fiction, Mrs. Todd uses her stories to bring together people separated by physical distance, misunderstanding, and even death. Katherine Anne Porter's Miranda stories reveal the power of community to connect family members to the past, and also to reorder that past in either destructive or positive ways. In *Their Eyes Were Watching God,* Zora Neale Hurston uses a frame narration to reveal not only the events of Janie's life, but Janie's reconstruction of those events as she shares them with her "kissin'-friend" Phoeby. Each of these writers uses stories to counter traditional, and thus authoritative, stories about spirituality, replacing these stories with alternative truths that enact the spiritual in their female characters' lives.

Overcoming separation through storytelling forms a central theme in a number of Sarah Orne Jewett's short stories. The fragile community of Jewett's fictional world is constantly threatened by distance and separation, whether caused by bad weather, misunderstanding and argument, or illness. In Jewett's story "The Foreigner," published in 1900, a storm at sea moves Mrs. Todd to seek shelter and company by the fireside of her friend and boarder, the story's narrator. In Dunnet Landing, a late summer storm portends the "sad end" of summer and the onset of a long, cold autumn and winter (157). It also raises the possibility of "danger offshore among the outer islands," and Mrs. Todd frets over the safety of her brother William, a fisherman, and her elderly mother, who live alone on remote Green Island (157). Beset by thoughts of death, Mrs. Todd reflects on another loss from her past: "This makes me think o' the night Mis' Cap'n Tolland died. . . . Folks used to say these gales only blew when somebody's a-dyin', or the devil

was a-comin' for his own" (160). Anxious to distract her worried friend, the narrator asks Mrs. Todd to tell a ghost story; immediately, however, she regrets the request, fearing, "[S]he was going to tell me something that would haunt my thoughts on every dark stormy night as long as I lived" (160). Mrs. Todd's "ghost story," however, proves not to be a horrifying tale, but one that calms both the teller and the listener by reassuring them of the power of community to transcend even death.

In "The Foreigner," Jewett depicts storytelling as a cyclical process through which the deepest secrets of the heart are only gradually revealed. Mrs. Todd's story is multilayered: in each of the story's numbered sections, she essentially retells the story of the death of Mrs. Tolland, a "foreigner" from Jamaica who married a local sea captain and came with him to Dunnet Landing. Each time she begins the story anew, however, Mrs. Todd reveals more significant details: Mrs. Tolland's isolation in Dunnet Landing because of her foreign looks, speech, and customs; Mrs. Todd's lesson from her own mother about kindness to this "stranger in a strange land" (169); Captain Tolland's death and Mrs. Tolland's rapid decline in health; and, finally, the ghostly appearance of Mrs. Tolland's mother on the night of her daughter's death. Jewett attributes this gradual process of revelation, in part, to Mrs. Todd's increasing confidence in the narrator as a listener. Each time Mrs. Todd pauses in the telling, the narrator prompts her, either with a gentle question which reveals both her interest and her understanding, or, on occasion, with silence, recognizing those times in which a "poor and insufficient question" is "worse than none" (162). "I ain't told you all," Mrs. Todd confesses as her story grows more confidential; "no, I haven't spoken of all to but very few" (182). Storytelling is thus important not only for the truths the teller reveals, but because the process itself enacts a deepening connection between teller and listener.

Dunnet Landing's condemnation of Mrs. Tolland represents a rare failure of community in Jewett's text. Mrs. Todd's story thus serves, too, as a parable meant to instruct her young friend about the sacred function of community. Remembering her own participation, as a young woman, in Dunnet Landing's prejudice toward Mrs. Tolland, Mrs. Todd recalls that she learned from her mother, Mrs. Blackett, about the need for kindness and tolerance toward a "foreigner." As in

Jewett's story "Poor Joanna," maternal love serves in "The Foreigner" as a source of spiritual comfort. When Mrs. Blackett comforts and befriends Mrs. Tolland, a rare sharp exchange between mother and daughter follows as Mrs. Blackett uses biblical language to insist on the sacred responsibility of a community to care for its members: "I want you to neighbor with that poor lonesome creatur'," Mrs. Blackett admonishes:

> "She's a stranger in a strange land. . . . What consequence is . . . your comfort or mine, beside letting a foreign person an' a stranger feel so desolate; she's done the best a woman could do in her lonesome place, and she asks nothing of anybody except a little common kindness." (169)

It is Mrs. Blackett who gives comfort to the brokenhearted Mrs. Tolland when Captain Tolland leaves for his last voyage at sea; later, Mrs. Tolland proclaims to Mrs. Todd that her mother is "an angel" (170). When Mrs. Tolland is dying, it is Mrs. Blackett who brings "the only comfort," locating a priest to visit the suffering woman (173).

After her mother's admonishment, Mrs. Todd feels "dreadful ashamed"; responding to her mother's urging, she pays a visit to Mrs. Tolland (169). Although Mrs. Tolland's customs initially seem strange, Mrs. Todd comes to value her "foreign" knowledge of cooking, medicinal herbs, and flowers. So moved is Mrs. Tolland by this unaccustomed show of friendship that, upon her death, she leaves her entire estate to Mrs. Todd; Mrs. Todd confesses that she considers this "sacred money; 'twas earnt and saved with the hope o' youth, an' I'm very particular what I spend it for" (181). From her mother, Mrs. Todd thus learns to place friendship in the realm of the "sacred." Years later, she lives out this lesson in her friendship with the narrator, another "stranger in a strange land." Using the lessons about community and friendship learned from her own mother, Mrs. Todd creates a place for her friend in the community and teaches her lessons about both physical and spiritual healing.

Only in the final segment of "The Foreigner" does Mrs. Todd's story evolve into the ghost story the narrator had requested. Rather than being the frightening tale she had dreaded to hear, however, this ghost story suggests the comfort to be found in the proximity of the temporal

and spiritual worlds. On the night when Mrs. Tolland dies, both she and Mrs. Todd see the ghost of Mrs. Tolland's mother: "a woman's dark face lookin' right at us" (184); "twas a pleasant enough face, shaped somethin' like Mis' Tolland's, and a kind of expectin' look" (86). When Mrs. Tolland assures Mrs. Todd that the woman they have seen is her mother, Mrs. Todd says, "[I] felt calm . . . an' lifted to somethin' different as I never was since" (186). She reassures Mrs. Tolland, *"[Y]ou ain't never goin' to feel strange an' lonesome no more"* (186). Rather than being frightening, the ghost suggests the power of maternal love to transcend even death.

Throughout "The Foreigner," the tale and the frame are interwoven as Jewett blurs the boundaries between the teller and her subject. Mrs. Todd punctuates her story throughout with the phrase, "'Twas just such a night as this Mis' Tolland died"; as the storm raging outside mirrors the tumultuous tale being related within, Mrs. Todd's house itself rocks and creaks like a ship at sea, pitching about "in a strange, disturbing way" (161). By the time the story is finished, however, a calm has settled both within and without the little house. "Sometimes these late August storms'll sound a good deal worse than they really be," Mrs. Todd comments. "[T]hey'll find it rough at sea, but the storm's all over" (187). The storm within has calmed, too: initially fearful of losing her mother, Mrs. Todd has been comforted by the story of Mrs. Tolland and the proximity of earthly and spiritual worlds. "When folks is goin' 'tis all natural," she assures the narrator. "You know plain enough there's somethin' beyond this world; the doors stand wide open" (187). Mrs. Todd's story thus functions to preserve community, forging and strengthening ties among herself, the narrator, Mrs. Blackett, and even the long-dead Mrs. Tolland.

In Jewett's "Miss Tempy's Watchers," similarly, storytelling creates connections not only among the living, but between the living and the dead. The story takes place the night before Miss Tempy Dent's funeral, when Miss Binson and Mrs. Crowe are "watching" in Tempy's house. Although the two women were Tempy's closest friends, they have little in common: Sarah Ann Binson is poor, charitable, long-suffering, and cheerful; Mrs. Crowe is well-to-do, critical, and stingy. Tempy herself had asked the two to sit up with her on this night in the hope "that they might become closer friends . . . and that the richer woman might bet-

ter understand the burdens of the poorer" (243). While Mrs. Crowe is indeed transformed during this night, the change results less from Miss Binson's influence than from what she learns from her friend Miss Tempy, whose life the two recreate through storytelling.

As in "The Foreigner," in "Miss Tempy's Watchers" the process of storytelling brings about new levels of intimacy between the listener and teller. As is usual in Jewett's fiction, confidences are exchanged in intimate domestic spaces—here, in Miss Tempy's kitchen, rather than in the "unused best room" (241). Although not close friends before this night, Mrs. Crowe and Miss Binson "had risen to an unusual level of expressiveness and confidence. Each had already told the other more than one fact that she had determined to keep secret; they were again and again tempted into statements that either would have found impossible by daylight" (242). Through their stories, the two women create a community which includes both the living and the dead. Miss Tempy herself seems to be keeping company with them; they speak "as if there were a third person listening" and "could not rid their minds of the feeling that they were being watched themselves" (243). "I feel as if the air was full of her, kind of," remarks Miss Binson, although dismissing the idea of "sperits" as "nonsense." "I can sense things, now and then, that she seems to say" (248). Stories thus function to keep the beloved friend alive so long as she is remembered and her stories are told.

Just as storytelling serves in "Miss Tempy's Watchers" to preserve ties between the living and the dead, it also reinforces the sense of community among the living. As the two women exchange stories about Miss Tempy, Mrs. Crowe begins to examine her own stingy ways and to feel more sympathetic toward Miss Binson. Among Miss Tempy's many kindnesses that the two friends recall, the "biggest thing she ever done," according to Miss Binson, was to give a young girl sixty dollars to take a vacation when she came home sick and exhausted after putting herself through school (245). Recalling that Miss Tempy only received ninety dollars a year in addition to what she raised on her small patch of land, Mrs. Crowe declares, "Say what you may, I feel humbled to the dust" (246).

Jewett creates a wry parallel between the recalcitrant Mrs. Crowe and Miss Tempy's thorny old quince tree, from which she was always

able to coax a harvest: "she'd go out in the spring and tend to it, and look at it so pleasant and kind of expect the old thorny thing into bloomin'," Mrs. Crowe explains (251). Through her kind and generous spirit, recreated through the stories told by her two friends, Miss Tempy similarly coaxes thorny old Mrs. Crowe into "bloomin'." When Miss Binson drops off to sleep, Mrs. Crowe looks upon her "with a new sympathy for the hard-worked little woman" (253). By arranging for her two friends to spend this night together, Miss Tempy has thus encouraged Mrs. Crowe's better nature to blossom.

As in "The Foreigner," storytelling in "Miss Tempy's Watchers" also serves to assuage fears of death. Mrs. Crowe, a less experienced "watcher" than Miss Binson, trembles as the two go upstairs to look at Tempy and recalls that Tempy herself "was one that always feared death" (250). In order to comfort Mrs. Crowe, Miss Binson reports on her last conversation with Miss Tempy: "'I'm only a-gettin' sleepier and sleepier; that's all there is,' says she, and smiled up at me kind of wishful, and shut her eyes. I knew well enough all she meant. She'd been lookin' out for a chance to tell me. . . ." Miss Binson thus uses a story about Miss Tempy to reassure Mrs. Crowe that dying is "as natural as bein' born or livin' on" (250). In "Miss Tempy's Watchers," storytelling strengthens and preserves community ties which transcend social and economic barriers, and even death.

Storytelling similarly serves as a gift that preserves community in Jewett's "A Dunnet Shepherdess." When the narrator agrees to go on a fishing trip with William, Mrs. Todd's brother, she finds herself involved in "a serious chapter of romance" between William and Esther, a shepherdess who lives "up country" and whom William sees only once a year. In order to gain permission to visit with Esther, William must first provide company for her mother, a formidable matriarch with "the features of a warlike Roman emperor" (148). When this severe, unsmiling woman releases William to go and search for Esther, he exits quickly, leaving the narrator behind. When she discovers that she has been an unwitting accomplice to William's scheme, providing a rare opportunity for him to visit with Esther alone, the narrator is "[a]t first . . . provoked and then amused . . . and a thrill of sympathy warmed [her] whole heart" (152). Having learned the art of a good visit

from Mrs. Todd, the narrator is well equipped to entertain her home-bound hostess with stories of deaths, weddings, and other news from Dunnet Landing.

During her visit, the narrator's storytelling art forges a sympathetic connection with her hostess, and even with the absent Esther. The narrator's receptiveness as a listener establishes such a friendship between herself and Mrs. Hight that the old woman becomes "more and more communicative": "[she] went carefully into the genealogical descent and personal experience of many acquaintances, until between us we had pretty nearly circumnavigated the globe and reached Dunnet Landing from an opposite direction to that in which we had started" (151). By the time Esther and William reappear at last, Mrs. Hight has been transformed by this sympathetic connection; she tells her daughter, as the narrator recounts, "that she had enjoyed a beautiful call, and got a great many new things to think of. This was said so frankly in my hearing that it gave a consciousness of high reward, and I was indeed recompensed by the grateful look in Esther's eyes. We did not speak much together, but we understood each other" (154–55). Having been briefly in Esther's place, the narrator's sympathy and understanding extend to her difficult life as well: "I had seen enough of old Mrs. Hight to know that nothing a sheep might do could vex a person who was used to the uncertainties and severities of her companionship" (154).

In Jewett's "Aunt Cynthy Dallett," similarly, storytelling serves both to preserve community and to convey moral lessons about care and friendship. When Abby Pendexter makes the long walk to her aunt Cynthy's home with her friend Mrs. Hand, several details in the text signify the importance of the journey. The two friends make their visit on New Year's Day, a day which both associate with fond family remembrances and with resolutions. Further, like Chaucer's travelers on a pilgrimage, the women exchange stories along the way to speed their journey. Most important in establishing the moral nature of this story, however, is the parable-like tale of her long-ago visit to Mrs. Fulham which Mrs. Hand tells to Abby. When Mrs. Hand responded to her friend Mrs. Fulham's frequent invitations to visit by appearing one afternoon at tea time, she reports, her friend seemed pleased to see her unexpected guest. She immediately withdrew into the kitchen to prepare the

tea, however, leaving Mrs. Hand alone in her "best room" for more than two hours. When the hostess finally reappeared to usher her guest in to a beautiful and elaborate tea, only a short time remained for visiting:

> "We set down together, an' I'm sure I appreciated what she's done; but 'twa'n't no time for real conversation whilst we was to the table, and before we got quite through . . . I had to leave . . . she said quite hearty that she'd had a nice visit from me. She appeared well satisfied, Mis' Fulham did; but for me, I was disappointed; an' early that fall she died." (288)

Mrs. Hand's story is thus a cautionary tale about the true value of visiting; Mrs. Fulham's death underscores the poignancy of this lost opportunity.

Abby Pendexter's response to this story highlights its moral nature by drawing a parallel to the Bible: laughing heartily, she comments, "'Better a dinner o' herbs.' I guess that text must ha' risen to your mind in connection" (288). The proverb to which Abby refers—"Better is a dinner of herbs where love is than a fatted ox and hatred with it"—emphasizes, similarly, the valuing of relationship over feasting. As might be expected, Abby's visit with her aunt Cynthy Dallett is transformative, providing an opportunity for Abby to draw on this story's moral lesson. Abby, who is in desperate economic circumstances, has nonetheless brought her last hen—"roasted just as nice as I know how"—for her aunt's dinner (284). While this gift is indeed welcome, it is the gift of the visit itself that brings Aunt Cynthy the greatest pleasure. When Abby agrees to give up her own home in order to come care for her aunt, she finds that she is "happy as a child" at giving this greatest gift of love and companionship (296).

In "Aunt Cynthy Dallett," as in virtually all of Jewett's tales, storytelling effects transformation by reinforcing values central to the life of the community. In these stories, the community, rather than the individual, forms the focus of the text. Questing is replaced by visiting, an activity which strengthens community by drawing in those who live on its periphery. Storytelling in these texts links both listeners and tellers to their most deeply held values, dispelling anger and prejudice and reinforcing the commitment to love, friendship, and care. Further, the

stories told by Jewett's characters help to maintain memories of the dead, thus linking the living to the world beyond. Storytelling thus functions in Jewett's text as a ritual of enactment, creating transformative ties among her characters.

Most critical assessments of *Their Eyes Were Watching God* treat Zora Neale Hurston's novel as the story of Janie Crawford's romantic quest, beginning with her sexual awakening under a flowering pear tree and ending with the death of her true love, Tea Cake Woods. To read Janie's story in this way, however, is to ignore its frame: *Their Eyes Were Watching God* is also a story about storytelling. Hurston begins her narrative by deliberately and self-consciously contrasting the life stories of women with those of men:

> Ships at a distance have every man's wish on board. For some they come in with the tide. For others they sail forever on the horizon, never out of sight, never landing until the Watcher turns his eyes away in resignation, his dreams mocked to death by Time. That is the life of men.
>
> Now, women forget all those things they don't want to remember, and remember everything they don't want to forget. The dream is the truth. Then they act and do things accordingly. (1)

This narrative, Hurston makes clear, is a woman's story: "So the beginning of this was a woman . . ."(1). Rather than ending with Tea Cake's death, Hurston thus suggests that Janie's life *begins* with Tea Cake's death, for it is at this point that Janie begins to reconstruct and give meaning to the events of her life. Janie's story is not just a romantic quest, therefore, but a spiritual quest for meaning.

In Hurston's text, the reader learns of the events of Janie's life not as she lives them, but as she recounts them to her friend Phoeby. Rather than merely serving as a vehicle for relating information, the storytelling process also effects transformation in both teller and listener. Because the porch-sitting citizens of Eatonville look critically at Janie upon her return

and speculate about what has happened to her, she refuses to share her story with them. "[P]eople like dem wastes up too much time puttin' they mouf on things they don't know nothin' about . . ." Janie complains. "If they wants to see and know, why they don't come kiss and be kissed?" (6). Janie, like Jewett's Mrs. Tolland, requires a receptive listener to tell her story, and Phoeby is the "kissin'-friend" who fulfills that role. Unlike the others, Phoeby refuses to speculate about Janie's life: "[N]obody don't know if it's anything to tell or not. Me, Ah'm her best friend, and *Ah* don't know" (3). In order to facilitate the storytelling, Phoeby does not ask curious questions, but arrives at Janie's "intimate gate" with a plate of mulatto rice and a warm welcome. Her "hungry listening," Hurston reports, "helped Janie to tell her story" (10).

As in Jewett's stories, in *Their Eyes* both the listener and the teller are transformed by the process of storytelling. Phoeby has not shared in Janie's adventurous life, and she is "eager to feel and do through Janie" (6). When Janie has finished telling her story, Phoeby proclaims, "Lawd . . . Ah done growed ten feet higher from jus' listenin' tuh you, Janie. Ah ain't satisfied wid mahself no mo'. Ah means tuh make Sam take me fishin' wid him after this" (182–83). Unlike the rest of the community, who are "parched up from not knowin' things," Phoeby participates vicariously in Janie's adventures and is, accordingly, transformed by them (183). Phoeby also serves to reconnect Janie to the community from whom she is alienated because of their suspicion and jealousy—their refusal to "come kiss and be kissed." Phoeby "belongs" both to Janie and to the community and will thus serve as Janie's mouthpiece: "You can tell 'em what Ah say if you wants to. Dat's just de same as me 'cause mah tongue is in mah friend's mouf" (6). As it is passed on, Janie's story can benefit not only Phoeby, but the entire community.

Although Janie is the clear protagonist of Hurston's novel, she emerges only gradually into the role of heroine in her own story. First, she must reject the supporting roles she is called upon to play in the stories of those around her. Janie marks the beginning of her "conscious life" at age sixteen, when she experiences a sexual awakening (10). Lying under a pear tree, she senses for the first time the connection between her own developing body, with its "glossy leaves and bursting buds," and the larger world outside her gated yard (11). Viewing

her own limited sphere through a haze of pollen, Janie sees the formerly "shiftless" Johnny Taylor transformed into the hero of her still-vague romantic dreams. When she kisses Johnny, Janie confronts her first opposing voice: that of her grandmother, Nanny, who has raised her. When Nanny spies the fateful kiss, she rewrites the story of Janie's first romantic venture:

> "Ah don't want no trashy nigger, no breath-and-britches, lak Johnny Taylor usin' yo' body to wipe his foots on."
>
> Nanny's words made Janie's kiss across the gatepost seem like a manure pile after a rain. (12)

By recasting the "beglamored" Johnny Taylor as a "trashy nigger" and Janie's first kiss as a smelly manure pile, Nanny usurps the "telling" of Janie's story.

Temporarily taking over the story's narrative voice, Nanny reveals that she, too, had once had a story to tell:

> "Ah wanted to preach a great sermon about colored women sittin' on high, but they wasn't no pulpit for me. Freedom found me wid a baby daughter in mah arms, so Ah said Ah'd take a broom and a cook-pot and throw up a highway through de wilderness for her. She would expound what Ah felt. But somehow she got lost offa de highway and next thing Ah knowed here you was in de world. So whilst Ah was tendin' you of nights Ah said Ah'd save de text for you." (15–16)

Although Nanny views her story as an inheritance to be passed along to her granddaughter, her authoritative voice serves only to silence and confine Janie. Within the grandmother's narrative framework, the only safe place for her sexually mature granddaughter is in marriage to the socially respectable but unappealing Logan Killicks. When, in a tentative attempt to tell her own story, Janie complains, "Ah wants things sweet wid mah marriage lak when you sit under a pear tree and think," Nanny scolds her into silence (23).

Within the traditional framework of the romantic quest, sexual awareness is a marker of the protagonist's coming of age. Thus, when Nanny spies Janie's first kiss, she tells her, "[Y]ouse uh 'oman now" (12). Janie, however, recognizes herself as a woman only when she

learns her first hard truth about life after marriage to Logan: "She knew now that marriage did not make love. Janie's first dream was dead, so she became a woman" (24). Janie's quest is thus associated less with romance than with acquiring truth and knowledge. By the time she leaves Logan to run off with Joe Starks, Janie has already abandoned some of the romantic illusions of her adolescence and set new goals for her quest. She knows that Joe is not the fulfillment of her romantic dreams: "[H]e did not represent sun-up and pollen and blooming trees, but he spoke for far horizon. He spoke for change and chance" (28). For Janie, Joe is no romantic ideal, but he provides a way out of her loveless marriage and into life.

Like Nanny, however, Joe expects Janie to play a role in his life story rather than writing her own. "Ah told you in de very first beginnin' dat Ah aimed tuh be uh big voice," Joe claims. "You oughta be glad, 'cause dat makes uh big woman outa you" (43). In time, Janie learns that Joe's "big voice" requires her own silence. When the townspeople invite her to make a speech, Joe interrupts: "Thank yuh fuh yo' compliments, but mah wife don't know nothin' 'bout no speech-makin'. Ah never married her for nothin' lak dat. She's uh woman and her place is in de home" (40–41). Although Janie "had never thought of making a speech, and didn't know if she cared to make one at all," she is chilled by Joe's silencing of her "without giving her a chance to say anything one way or another" (41). Through her silencing, Janie is thus forced to play a supporting role in the story of Joe's heroic quest.

As she begins chafing under the restrictions that Joe places on her, Janie discovers that her voice is her most powerful weapon against him. When a group of men at the store sit about defending their right to hit their wives, Janie "thrust herself into the conversation" for the first time:

> "Sometimes God gits familiar wid us womenfolks too and talks His inside business. He told me how surprised He was 'bout y'all turning out so smart after Him makin' yuh different; and how surprised y'all is goin' tuh be if you ever find out you don't know half as much 'bout us as you think you do. It's so easy to make yo'self out God Almighty when you ain't got nothin' tuh strain against but women and chickens." (70–71)

In response to this speech, Joe sends Janie into the store, telling her that she is getting "too moufy" (71). Janie, however, has discovered the power of her own voice, and it is this truthful voice that ultimately kills Joe Starks. Having been repeatedly humiliated by Joe in front of the community, Janie publicly discredits his voice and asserts her own: "You big-bellies around here and put out a lot of brag, but 'tain't nothin' to it but yo' big voice. . . . When you pull down yo' britches, you look lak de change uh life" (75). At this insult to his "illusion of irresistible maleness," Joe's "vanity bled like a flood" (75). Soon afterward, Joe takes to his bed, eventually dying of kidney failure.

As she later prepares to tell her story, Janie gradually comes to define her dreams apart from the men she has looked to to fulfill them. When Joe slaps her for burning his dinner, Janie sees "that it never was the flesh and blood figure of her dreams. Just something she had grabbed up to drape her dreams over" (68). Janie plays her wifely role for Joe's funeral, but she has come to recognize the distinction between this role and her true self:

> Janie starched and ironed her face and came set in the funeral behind her veil. It was like a wall of stone and steel. The funeral was going on outside. . . . Inside the expensive black folds were resurrection and life. . . . She sent her face to Joe's funeral, and herself went rollicking with the springtime across the world. (84–85)

While Joe had once appeared to Janie as a chance for escape from her oppressive life, it is now freedom from Joe that Hurston casts as "resurrection and life." Janie's journey is toward her own transformation, and Joe's death now moves her farther toward that goal.

Janie's relationship with Tea Cake Woods serves as yet another step in her quest for self-knowledge. For the first time, Janie loves a man who seems to fulfill her adolescent vision: "He looked like the love thoughts of women. He could be a bee to a blossom—a pear tree blossom in the spring. . . . He was a glance from God" (101–2). With Tea Cake, Janie participates fully in the folk life that she craves and from which Joe had excluded her. In the Everglades, Janie abandons her

apron for a pair of overalls and works beside Tea Cake and the rest of the community in the fields. Here, too, she develops her storytelling voice: "The men held big arguments here like they used to do on the store porch. Only here, she could listen and laugh and even talk some herself if she wanted to. She got so she could tell big stories herself from listening to the rest" (127–28).

Although most critics have viewed Tea Cake as the romantic hero of *Their Eyes Were Watching God,* Janie's third marriage forms the most problematic and controversial aspect of Hurston's text. While Janie is indeed happier and more autonomous in her relationship with Tea Cake than in either of her previous marriages, she is nonetheless, as Mary Helen Washington writes, "at times so subordinate to the magnificent presence of Tea Cake that even her interior life reveals more about him than about her" (xiv). Initially, Janie is merely submissive; she tells Phoeby, "[U]s is goin' off somewhere and start all over *in Tea Cake's way*" (108; emphasis mine). Tea Cake has even picked out Janie's clothes: "Wait till you see de new blue satin Tea Cake done picked out for me tuh stand up wid him in. High heel slippers, necklace, earrings, *everything* he wants tuh see me in" (109–10). In time, however, Tea Cake's dominance escalates into a possessive jealousy, and he beats Janie:

> Not because her behavior justified his jealousy, but it relieved that awful fear inside him. Being able to whip her reassured him in possession. No brutal beating at all. He just slapped her around a bit to show he was boss. (140)

This scene recalls vividly the earlier one in Joe's store when the men discuss the virtues of beating their women and scorn their friend Tony for failing to exercise this male privilege—a scene which marked the first time that Janie "thrust herself into the conversation" (70).

Because Janie does not defend herself against Tea Cake's attack, many readers have accused Hurston of an "uncritical depiction of violence toward women" (Washington, Foreword xiv). Hurston's plot development, however, suggests more ambivalence than many critics acknowledge. When Tea Cake, mad with rabies, threatens Janie with a gun, she shoots him; then, after catching him in a final love embrace, she breaks the embrace to pry his teeth from her arm, thus saving herself not

only from Tea Cake's gun but from his rabid bite. The adolescent Janie, who prized love above all else, could never have fired a gun at her lover in order to save her own life, but the adult Janie acts not once but twice to save herself from Tea Cake's murderous frenzy. Although Hurston's treatment of violence is less overtly critical than a feminist reader might hope for—Janie never opposes Tea Cake or defends herself verbally—the mere fact that she kills off the text's supposed romantic hero calls into question the notion that Hurston is entirely "uncritical" of Tea Cake. This plot twist also belies the categorization of *Their Eyes Were Watching God* as a romance. As Claire Crabtree writes in "The Confluence of Folklore, Feminism and Black Self-Determination in Zora Neale Hurston's *Their Eyes Were Watching God*," "Janie needs freedom and an expansion of her horizons more than she needs love" (57). Yet, Hurston's novel has never been primarily about love, but about a woman's construction of her own reality; as she writes in the opening paragraphs of her narrative, "So the *beginning* of this was a woman and she had come back from burying the dead" (1; emphasis mine). Janie's story, her reconstruction of her own life, thus begins with Tea Cake's death.

In the novel's final paragraphs, Hurston reminds the reader that this story is not only about Janie's life experience, but about her reconstruction of that experience. Tea Cake may be dead, but within the narrative frame of Janie's story, he lives on in the power of her memory and imagination:

> Then Tea Cake came prancing around her where she was and the song of the sigh flew out of the window and lit in the top of the pine trees. Tea Cake, with the sun for a shawl. Of course he wasn't dead. He could never be dead until she herself had finished feeling and thinking. (183)

Like the mythical women of Hurston's opening paragraphs, Janie is a woman who reinvents her own life according to the truths dictated by her dreams. While the real-life Tea Cake beats Janie and, in his madness, nearly kills her, the one she retains in her dreams is the Tea Cake who fulfilled her romantic vision of the pear tree.

Like Jewett's Dunnet Landing, the world of Katherine Anne Porter's Miranda stories is peopled by ghosts. Porter's protagonist, Miranda Rhea, is caught between two generations, a present in which she must live and a past to which she is inextricably tied by the powerful bonds of family. This family, including members long dead before Miranda was born, is kept alive in her life through the tradition of family storytelling. In "Old Mortality," Porter claims that Miranda and her sister Maria "had long since learned to draw the lines between life, which was real and earnest . . . poetry, which was true but not real; and stories" (139). In the course of the story, however, Porter reveals the naiveté of this assertion. Even as young children, Miranda and Maria experience the blurred boundaries between themselves and their ancestors: They "knew they were young, though they felt they had lived a long time. They had lived not only their own years; but their memories, it seemed to them, began years before they were born, in the lives of the grown-ups around them" (108). While this storytelling tradition provides Miranda with a rich sense of family history, it also forces her to grapple with a constructed reality that blurs distinctions between past and present, truth and legend, the living and the dead. As Miranda stands on the brink of adulthood at the end of Porter's story, she struggles to reconcile these seemingly dichotomous forces in her life.

While Porter depicts storytelling as potentially transformative, she also reveals its potential for distorting both past and present. Even as a child, Miranda recognizes the blending of truth and fiction in her family's stories. Her father, for example, insists that "[t]here were never any fat women in the family," an observation which Miranda herself can easily refute (108). Similarly, the portraits and photographs lining the walls of her grandmother's home seem to bear little resemblance to the heroes and heroines of family legend. While Aunt Amy, according to her father's stories, "had been beautiful, much loved, unhappy, and . . . had died young," Miranda finds her portrait unimpressive (108). Even her father observes of the photograph, "It's not very good. Her hair and her smile were her chief beauties, and they aren't shown at all. She was much slimmer than that, too" (108). The true import of Miranda's family history is captured not in photographs, but in stories:

No, Maria and Miranda found it impossible to sympathize with those young persons, sitting rather stiffly before the camera, hopelessly out of fashion; but they were drawn and held by the mysterious love of the living, who remembered and cherished these dead. . . . They listened, all ears and eager minds, picking here and there among the floating ends of narrative, patching together as well as they could fragments of tales that were like bits of poetry or music, indeed were associated with the poetry they had heard or read, with music, with the theater. (111)

The heroes and heroines of family history are thus products of storytelling, amalgams of their own histories and the loving imaginations of their ancestors.

When she meets some of the characters of family legend, Miranda learns not only that the present distorts the past, but that the past can have a crippling effect on those who must live in the present. Her uncle Gabriel is no longer the dashing suitor of their romantic Aunt Amy, but a sad, drunken man whose inability to recover from Amy's death has resulted in a life of despair and ruin. Meeting his nieces for the first time, many years after Amy's death, he cries, "Pretty as pictures . . . but rolled into one they don't come up to Amy, do they?" (145). Gabriel's second wife, Miss Honey, has been driven to a deep bitterness by Gabriel's continued obsession with Amy, his drinking, and their life of poverty and despair. Even when Gabriel dies, years later, he is buried beside Amy, thus consummating what Cousin Eva terms a "life-long infidelity" (166). Confronted by this "vast bulging man," with his "red face and immense tan ragged mustaches fading into gray," Miranda is frustrated and confused by the seemingly irreconcilable worlds of past and present: "Oh, what did grown-up people *mean* when they talked, anyway?" (144).

Miranda's Cousin Eva, too, confronts her with the potentially distorting effects of the past on the present. As the ugly duckling of the family, the "shy and chinless" Eva spent her girlhood looking on while the other young women attended parties, had romances, and married (114). While Aunt Amy "belonged to the world of poetry," Cousin Eva is part of the "everyday world of dull lessons to be learned, stiff

shoes to be limbered up, scratchy flannels to be endured in cold weather, measles and disappointed expectations" (115). When Miranda and Eva meet on a train bound home for Gabriel's funeral, Miranda barely remembers having met this older cousin, but the stories told about her over the years crowd into her mind like a flood of voices from the past:

> Aunt Amy had threatened to be an old maid like Eva. Oh, Eva, the trouble with her is she has no chin. Eva has given up, and is teaching Latin in a Female Seminary. Eva's gone out for votes for women, God help her. The nice thing about an ugly daughter is, she's not apt to make me a grandmother. (161)

While Eva meets all of Miranda's expectations, she simultaneously dispels Miranda's view of Amy as a fiction, from her legendary beauty ("She always got herself up to be looked at, and so people looked, of course") to her mysterious death (172). While family legend maintains that Amy "faded like a lily" in her final illness, Eva points out that she "coughed blood, if that's romantic" (172); and, while Miranda knows from family stories that Amy died of a hemorrhage, Eva exposes her death as a probable suicide: "Amy did away with herself to escape some disgrace, some exposure that she faced. . . . She got into trouble somehow, and she couldn't get out again, and I have every reason to believe she killed herself" (171).

Miranda, however, recognizes that Eva's account of the past is as much a fiction as the family stories that she herself was brought up on. While the "official" version of the family history "had its springs in family feeling and a love of legend," Eva's stories are just as deeply rooted in bitterness. Her anger seems to Miranda "much too deep for this one cause" as Eva cries, "Can you imagine . . . people who call themselves civilized spoiling life for a young girl because she had one unlucky feature? . . . Ah, the family . . . the whole hideous institution should be wiped from the face of the earth. It is the root of all human wrongs" (175–76). While Eva cautions Miranda against living in a "romantic haze about life," she, too, lives in the past, although a past clouded by bitterness (168). For both Gabriel and Eva, storytelling thus fails as a source of spiritual truth. Rather than creating connections

among members of the community, their stories prevent those connections by distorting the past, whether through idealization or anger.

At the end of Porter's story, Miranda stands at a crossroads, a point at which she must determine what her relationship to her family and to the past will be. Perhaps in part because of the romantic allure of Amy's story, Miranda herself has run away from school to be married. Rather than finding herself the heroine of a family legend, however, she has disgraced herself in her father's eyes. Angry at his rejection of her, she determines to cut herself off from the smothering ties of family. Even Eva, however, demonstrates to Miranda the impossibility of this choice. After her bitter diatribe against the family, Eva is drawn back into its circle as soon as they are met at the train by Miranda's father— Eva's cousin and peer, Harry. Watching their reunion, it is Miranda who is the bitter outsider:

> They sat back and went on talking steadily in their friendly family voices, talking about their dead, their living, their affairs, their prospects, their common memories, interrupting each other, catching each other up on small points of dispute, laughing with a gaiety and freshness Miranda had not known they were capable of, going over old stories and finding new points of interest in them. (179–80)

Although she can hear only the murmur of their voices, Miranda feels that she already knows the stories they are telling: "She knew too many stories like them, she wanted something new of her own" (180).

In "Old Mortality," Porter suggests that if storytelling is to serve a sacred function, it must reflect a balance between connection to and separation from the past. As Miranda stands on the brink of adulthood, she must find this balance. In Miranda's final, angry words, Porter reveals her protagonist's naiveté:

> I don't want any promises, I won't have false hopes, I won't be romantic about myself. . . . Let them tell their stories to each other. Let them go on explaining how things happened. . . . At least I can know the truth about what happens to me, she assured herself silently, making a promise to herself, in her hopefulness, her ignorance. (182)

Miranda can no more cut herself off from these inherited stories than can Eva or her father, for it is stories that give meaning to the lives of Porter's characters. These stories, however, are never invented anew; they are constructed of collected bits and pieces of the past.

In Porter's "The Old Order," Miranda's grandmother and her servant Nannie use storytelling to knit together lives otherwise divided by race, education, and social class. When the grandmother is a child, Nannie is given to her by an indulgent father when she begs to have the "little monkey" he has purchased at a slave auction. The grandmother, however, rewrites this master-slave relationship by constructing a past for Nannie, whose origins, like those of most other slaves, are lost to history:

> [Nannie] would never have had a birthday to celebrate if Grandmother had not, when she was still Miss Sophia Jane, aged ten, opened a calendar at random, closed her eyes, and marked a date unseen with a pen. So it turned out that Nannie's birthday thereafter fell on June 11, and the year, Miss Sophia Jane decided, should be 1827, her own birth-year. (15)

Grandmother further revises Nannie's life story by literally writing her into the family in the pages of the family Bible: "[T]hough there was some uproar when this was discovered, the ink was long since sunk deeply into the paper. . . . There it remained, one of their pleasantest points of reference" (15). With her pen, Sophia Jane thus revises the traditional construction of her relationship to Nannie, rewriting it as something sacred: not a mistress and slave relationship, but an intimate and transforming friendship.

Although divided by the external constructs of race relations, Nannie and Sophia Jane are united by their shared experiences as women. As young brides, the two women engage in a "grim and terrible race of procreation," with Nannie, according to custom, nursing both children. When Nannie becomes ill, however, Sophia Jane breaks with this tradition, nursing both babies and "not favoring the white over the black, as Nannie felt obliged to do" (23). While Sophia Jane's husband and mother respond with shock and disapproval, Sophia Jane rejects traditional cultural constructions of race relations and, as she had when

she wrote Nannie's name in the family Bible, redefines their relationship on her own terms. In nursing these children, she discovers a truth that cultural conventions had hidden from her: "a sensual warm pleasure she had not dreamed of, translating her natural physical relief into something holy, God-sent, amends from heaven for what she had suffered in childbed" (24). In denying the truth of cultural prescriptions about race, Sophia Jane also uncovers hidden truths about the lives of women.

As old women, Grandmother and Nannie preside over the household; Porter refers to their choice of the side garden as the place to do their sewing as a "domestic strategy" which allows them to see virtually everything going on in the house. After so many years together, Grandmother and Nannie share an unspoken language, commenting on the goings-on around them with "an exchange of glances, a lifted eyebrow, or a tiny pause in their talk" (13). Here, too, Grandmother and Nannie reconstruct their past, united less by shared pleasures than by a mutual questioning of the sufferings each has endured:

> This unbroken thread of inquiry in their minds contained no doubt as to the utter rightness and justice of the basic laws of human existence, founded as they were on God's plan; but they wondered perpetually, with only a hint now and then to each other of the uneasiness of their hearts, how so much suffering and confusion could have been built up and maintained on such a foundation. (14)

Through stories and reminiscences, Sophia Jane and Nannie thus call into question the "truths" about race, gender, and God that govern their society, simultaneously inventing new truths based on their own life experiences as women. As they talk, they sew, for the two "shared a passion for cutting scraps of the family finery, hoarded for fifty years, into strips and triangles, and fitting them together again in a carefully disordered patchwork" (11). Thus, through both their sewing and their storytelling, they reconstruct the past in an image of their own choosing.

"[T]here are always at least two stories to negotiate when reading women's fiction," Ann-Janine Morey writes in *Religion and Sexuality in American Literature,* "the story about life in a patriarchy and the responsive female voice inside the story about patriarchy. Both stories

are authentic to women's writing—living in relationship to androcentric norms and claiming distance at the same time" (200). In each of the works discussed here, female characters tell stories which, in some ways, respond to and resist traditional stories. Sarah Orne Jewett's tales relate not conventional stories of seafaring men, but domestic stories told by the women who are left behind. In *Their Eyes Were Watching God,* the quest ends with a return to community and the reintegration of the questing heroine into community through storytelling. In Katherine Anne Porter's stories, Grandmother and Nannie, Miranda and Eva subvert tales which would romanticize the past. In her essay "Zora Neale Hurston, Alice Walker, and the 'Ancient Power' of Black Women," Marjorie Pryse writes that both Hurston and Walker view fiction "as a form of conjuring" (2). I would argue that all of the storytellers represented here are conjurers, enacting the spiritual by countering traditional stories and inventing new ways of depicting the self in relation to the community.

Chapter V

The Wilderness
and the Garden

Here we are not quick to disavow
the pull of field and wood
and stream;
we are not quick to turn
upon our dreams.

—Alice Walker

To this point, I have examined spiritual quest as a study of quest itself, and of how, finding the quest metaphor inappropriate for their life circumstances or those of their female characters, many women writers have revised the quest narrative, substituting domesticity, community, and storytelling as alternative spiritual realms. I conclude by examining another aspect of spiritual quest: the wilderness into which the Adamic hero flees. Nature has, throughout literary history, served as a metaphor for the spiritual; the American Adam's wilderness is just one construction of that metaphor. Women writers, too, frequently associate nature with the spiritual. Their version of wilderness, however, is often a domesticated one, expressed in the gardens and other cultivated spaces over which their female characters preside.

In *The Lay of the Land,* Annette Kolodny explores both the genesis and the impact of the "land-as-woman" metaphor which dominates American literature from the discovery narratives to the present. While the earliest settlers routinely experienced "starvation, poor harvests, and inclement weather," their writings are nonetheless replete

with "images of abundance," the landscape being constructed as "a return to the primal warmth of womb or breast" (6). In her study, Kolodny emphasizes the usefulness of this metaphor in bringing settlers to this harsh new environment and helping them acclimate to it:

> [I]t brought successive generations of immigrants to strange shores and then propelled them across a vast uncharted terrain. For it is precisely those images . . . that have allowed us to put our human stamp on a world of external phenomena and, thereby, survive in the first place in a strange and forbidding wilderness. (147)

Echoes of this feminized landscape recur not only throughout the writings of discovery and settlement, but throughout American literary history.

In *The Land Before Her,* Kolodny continues her study of the symbolic landscape in American literature by studying the letters and diaries of women on the frontier. Most frontier women, Kolodny finds, did not share their male counterparts' gendered projections onto the wilderness landscape. Rather than seeing the land as comfortingly maternal, most women settlers found the wilderness a fearful place into which they unwillingly followed husbands, fathers, and brothers. The experience of many women on the frontier was that of being enclosed in small, dark cabins while men roamed the wilderness. "[D]uring her earliest years on this continent," Kolodny points out, "the Euro-American woman seems to have been the unwilling inhabitant of a metaphorical landscape she had had no part in creating—captive, as it were, in the garden of someone else's imagination" (5–6).

While women and men inhabited the same frontier, Kolodny asserts that their metaphorical constructions of that landscape, as found in their writings, are dramatically different. "'[P]aradise' implied radically different places when used by men and by women," Kolodny writes. "For men the term (with all its concomitant psychosexual associations) echoed an invitation for mastery and possession of the vast new continent. For women, by contrast, it denoted domesticity" (54). In comparing the narrative voice of Daniel Boone with that of Elizabeth House Trist, a woman who in 1784 traveled across the Allegheny Mountains to the frontier settlement at Pittsburgh, then down the Ohio and Mississippi

Rivers to Natchez, Kolodny finds that the primary differences which distinguish Trist's voice are "her studied avoidance of paradisal projections and her apparent inability to praise the Pennsylvania frontier simply for the beauty of its untouched wilderness state" (40).

Kolodny asserts that one element which seems to have helped women adapt to their new environment was the establishment of gardens. The regular exchange of seeds, cuttings, bulbs, and gardening advice evidenced by frontier women's correspondence demonstrates their efforts to "put their personal stamp on landscapes otherwise owned and appropriated by men" (48). While Kolodny's study addresses only the letters and diaries of frontier women, the image of the garden as an alternative spiritual realm also pervades fiction by women writers of the late-nineteenth and twentieth centuries. The substitution of the garden and other domesticated landscapes for the untamed wilderness is a recurring motif throughout American women's writing. In many of these works, spiritual truths are found not in the solitary wilderness quest, but in the domestication of a landscape that nurtures family and community.

In her essay "In Search of Our Mothers' Gardens," Alice Walker illuminates the appropriateness of this garden metaphor for women's lives. Writing of her mother's gift as a storyteller, Walker recalls the constant interruption of these stories by the press of her mother's daily obligations: "[S]tories . . . were subject to being distracted, to dying without conclusion. Dinners must be started, and cotton must be gathered before the big rains" (240). The mother's flower gardens, too, serve as an expression of her artistry: "[A]mbitious gardens . . . with over fifty different varieties of plants . . . A garden so brilliant with colors, so original in its design, so magnificent with life and creativity, that to this day people drive by our house in Georgia . . . and ask to stand or walk among my mother's art" (241). Gardening too, however, like storytelling, must be fitted into the beginnings and ends of days spent as a sharecropping field worker:

> Before she left home for the fields, she watered her flowers, chopped up the grass, and laid out new beds. When she returned from the fields she might divide clumps of bulbs, dig a cold pit,

uproot and replant roses, or prune branches from her taller bushes
or trees—until night came and it was too dark to see. (241)

Walker's essay recalls Bettina Aptheker's description of women's lives
as "fragmented and dispersed" and "episodic"; "Women are continu-
ally interrupted," Aptheker writes (39). While the questing American
Adam flees the restrictions imposed by family and communal ties, the
woman gardener accommodates these interruptions, producing a cul-
tivated landscape that mediates between the untamed wilderness and
the domestic realm.

In her essay, Walker makes clear that her mother's self-expression
as a gardener is not only artistic, but spiritual: "Whatever she planted,"
Walker recalls, "grew as if by magic" (241). The woman as gardener
thus has transfiguring power, transforming a "shabby house" into a shrine
for pilgrims who come to "stand or walk among my mother's art." As
a gardener, her mother assumes the divine power of Creator, "[o]rder-
ing the universe in the image of her personal conception of Beauty"
(241). This is no aloof, transcendent Creator, however, but one who
leaves to her daughter "a legacy of respect . . . for all that illuminates and
cherishes life" (241–42). The Creator is thus intimately connected to the
temporal world, both to nature and to the lives of her children.

Walker's essay also demonstrates the "seamlessness" that Helen
Levy observes in women writers' texts, wherein the domestic, natural,
and spiritual worlds form overlapping circles rather than separate spheres
(4). Within the spiritual quest tradition, the physical and spiritual worlds
are clearly demarcated. "The goal of this old 'sacred game,'" Elizabeth
Dodson Gray writes in *Sacred Dimensions of Women's Experience,* "is to
get away from the ordinary, the natural, the unsacred—away from
women, fleshly bodies, decaying nature, away from all that is rooted in
mortality and dying . . ." (2). For Walker's mother, however, spiritu-
ality is located in both the transcendent and the physical—in telling her
children sacred stories and in providing for their material needs. While
the American Adam's wilderness is a place set apart from everyday con-
cerns, the garden is inextricably connected to both the physical and
spiritual worlds. In Sarah Orne Jewett's *The Country of the Pointed Firs,*
Harriette Arnow's *The Dollmaker,* Toni Morrison's *The Bluest Eye,* and
Gloria Naylor's *Mama Day,* the garden forms a literary motif which

grows out of women's lives, shaped by home and community as well as by the natural world.

In Sarah Orne Jewett's *The Country of the Pointed Firs,* Mrs. Todd's garden serves as a central metaphor for the spiritual realm. The narrator describes her hostess's herb garden in mythic terms: Its "strange and pungent odors . . . roused a dim sense and remembrance of something in the forgotten past. Some of these might once have belonged to sacred and mystic rites, and have had some occult knowledge handed with them down the centuries . . ." (3–4). Mrs. Todd's herbal practice thus connects the present world with an ancient past and the temporal world with a spiritual world of "mystic rites." Jewett frequently refers to Mrs. Todd as a "sibyl," and her transformation from the earthly to the spiritual realm is also associated with her herbs: "She stood in the centre of a braided rug, and its rings of black and gray seemed to circle about her feet in the dim light . . . while the strange fragrance of the mysterious herb blew in from the little garden" (8). The spiritualized landscape in *Pointed Firs* is thus no wilderness, but a domesticated landscape of gardens.

While women are the central characters of Jewett's text, her occasional tales about men suggest a marked distinction between the wilderness of the male quest and women's domestic landscape. One such story is the tale of Captain Littlepage, an old sailor whom Mrs. Todd can never be prevailed upon to talk about except to say mournfully that he "used to be a beautiful man" (29). Captain Littlepage, unlike Mrs. Todd, attaches little value to domestic and communal life. He sees the decline of shipping as a sad loss to New England communities: "[A] community narrows down and grows dreadful ignorant when it is shut up to its own affairs," he tells the narrator (20). While the captain's years at sea may well have given him a wider view of the world than most of his Dunnet Landing neighbors, Jewett implies that the captain is also a man broken by his long years of solitude; the narrator describes him as a shipmaster "wrecked on the lee shore of age" (29). When he meets the narrator, Captain Littlepage tells her a strange tale of a sea voyage in which a fellow seafarer claims to have discovered "a strange sort of a country 'way

up north beyond the ice, and strange folks living in it. Gaffett believed it was the next world to this" (24). The captain's account is thus part quest tale, part supernatural story of a spiritual realm beyond the known physical world.

While Mrs. Todd's supernatural tales, such as the ghost story in "The Foreigner," serve as sources of comfort and connection to the community, Littlepage's story is frightening and disturbing; the captain himself classifies the tale as "something awful" (24). This world of spirits is inhabited not by much-mourned relatives and friends, as in "The Foreigner" and "Miss Tempy's Watchers," but by frightening "fog-shaped men" who terrorize the sailors who discover them. When the narrator returns home to tell of the captain's visit, Mrs. Todd brews her an herbal drink, and the narrator fears for a moment that Mrs. Todd's herbal potions may link her to the spiritual world witnessed by the captain: "I felt for a moment as if it were part of a spell and incantation, and as if my enchantress would now begin to look like the cobweb shapes of the arctic town." Mrs. Todd's supernatural powers, however, evoke not a lonely sea voyage into the wilderness, but domestic pleasures: "Nothing happened but a quiet evening and some delightful plans that we made about going to Green Island, and on the morrow there was the clear sunshine and blue sky of another day" (31).

The only sea voyage that Mrs. Todd makes in *Pointed Firs* is to Green Island, to visit her mother. Jewett clearly distinguishes between this maternal visit and the men's voyages when Mrs. Todd scornfully rejects the narrator's suggestion that they travel on Captain Bowden's boat: "[W]e don't want to carry no men folks havin' to be considered every minute an' takin' up all our time. No, you let me do; we'll just slip out an' see mother by ourselves" (32). While Mrs. Todd's boat is still far out at sea, the mother and daughter recognize one another with joy:

> I looked, and could see a tiny flutter in the doorway, but a quicker signal had made its way from the heart on shore to the heart on the sea.
>
> "How do you suppose she knows it is me?" said Mrs. Todd, with a tender smile on her broad face. "There, you never get over bein' a child long's you have a mother to go to." (35)

Although separated geographically, the mother and daughter thus share a spiritual connection which transcends physical space. Humorously, Jewett suggests a sort of telepathic mother–daughter conference on the homely domestic matter of preparing a chowder for lunch. Mrs. Todd catches a haddock on the way to the island and, inexplicably, brings along an onion from her kitchen windowsill; "That's just what I was wantin," Mrs. Blackett exclaims. "I give a sigh when you spoke o' chowder, knowin' my onions was out" (36). The spiritual journey is thus cast not as a lone wilderness quest, but as a pilgrimage undertaken to strengthen communal ties.

The narrator's first glimpse of Mrs. Blackett's home recalls Helen Levy's observation that the "home place" coexists "seamlessly" with the natural world, "women's domestic craft and nature's abundance enriching each other constantly. The American home place is established in a setting in which care of garden or field is viewed as growing out of labor in kitchen or nursery" (4). Mrs. Blackett's home, a virtual shrine to domesticity, seems, indeed, to be growing right out of the earth: "It was one of the houses that seem firm-rooted in the ground, as if they were two-thirds below the surface, like icebergs" (39). Her flower garden, too, Jewett describes as an outgrowth of the house itself: "there grew a mass of gay flowers and greenery, as if they had been swept together by some diligent garden broom" (39). Green Island, as its name implies, is closely tied to the natural world. No wilderness, however, it is a world in which the natural and the domestic are inextricably linked.

Mrs. Blackett's home is devoted not only to nature and to domestic practice, but also to community. As the narrator is ushered formally through the front door, she is surprised to find that Mrs. Blackett keeps a "best room":

> It was indeed a tribute to Society to find a room set apart for her behests out there on so apparently neighborless and remote an island. Afternoon visits and evening festivals must be few in such a bleak situation at certain seasons of the year, but Mrs. Blackett was of those *who do not live to themselves,* and who have long since passed the line that divides *mere self-concern* from a valued share in whatever Society can give and take. (41; emphasis mine)

Far from being a wilderness, the island which is the goal of Mrs. Todd's journey is a place set apart as a monument to domesticity and community. The climactic moment of the narrator's visit comes when Mrs. Blackett invites her to sit for a few moments in the rocking chair in her bedroom:

> There was a worn red Bible on the lightstand . . . her thimble was on the narrow window-ledge, and folded carefully on the table was a thick striped-cotton shirt that she was making for her son. . . . I sat in the rocking-chair, and felt that it was a place of peace, the little brown bedroom, and the quiet outlook upon field and sea and sky.
> . . . we understood each other without speaking. (54)

Thus, in the intersection of nature, domesticity, and spirituality, the narrator discovers "the real home, the heart of the old house on Green Island" (54).

Willa Cather's *O Pioneers!,* the story of a woman as frontier farmer, has been variously interpreted as the triumph of female over male, nurture over conquering, intellect over physical strength. In the context of the present study, it may also be read as the triumph of the gardener over the conventional farmer. Alexandra Bergson's farm is, on a literal level, an inheritance from her father, who inverts the traditional pattern of family inheritance by passing responsibility for the land to his daughter, rather than to either of his adult sons. Because John Bergson is ultimately a failure as a farmer, however, his legacy is insufficient to secure his daughter's success. Alexandra's unique relationship to the land—and the source of her success as a farmer—is in part an inheritance from her gardener-mother.

While John Bergson provides the opportunity for his daughter's success as a farmer, he cannot offer her a model for that success. His own relationship to the land is one of hostility and failure:

> In eleven long years John Bergson had made but little impression upon the wild land he had come to tame. It was still a wild thing

that had its ugly moods; and no one knew when they were likely
to come, or why. Mischance hung over it. Its Genius was
unfriendly to man. (20)

John Bergson suspects that the land persists in its untamed state because
"no one [understands] how to farm it properly" (22). The family patri-
arch knows that his sons—the indolent Oscar, who "rather liked to do
things in the hardest way," and the "fussy and flighty" Lou—can nei-
ther grasp this problem nor form solutions to it (55–56). In his daugh-
ter, however, Bergson recognizes the resourcefulness, intelligence, and
good judgment needed to succeed where he himself could not. Only
because of her father's legacy—his command to the sons that they "be
guided by [their] sister"—is Alexandra able to implement her farming
innovations (26).

Although Mrs. Bergson is a minor and somewhat shadowy figure
in the family drama at the center of Cather's opening chapter—the
reader never even learns her first name—Cather nonetheless writes
admiringly of the mother's adaptation to the wilderness. While Helen
Levy claims that "Alexandra's immigrant mother cannot offer her
daughter a pattern for homemaking on the prairies, which bear no mark
of cultural tradition and few marks of human continuity" (75), Cather's
text suggests otherwise. Mrs. Bergson is initially described in terms of
her likeness to her "heavy and placid" son Oscar. Unlike Oscar, how-
ever, whose "love of routine amounted to a vice" (55), Mrs. Bergson
has turned her habit-loving ways to the preservation of her family:

> For eleven years she had worthily striven to maintain some sem-
> blance of household order amid conditions that made order very
> difficult. Habit was very strong with Mrs. Bergson, and her
> unremitting efforts to repeat the routine of her old life among new
> surroundings had done a great deal to keep the family from disin-
> tegrating morally and getting careless in their ways. (28–29)

Like the frontier women of Kolodny's study, Mrs. Bergson accommo-
dates herself to the harsh land to which she has unwillingly followed
her husband by becoming a gardener: "Alexandra often said that if her
mother were cast upon a desert island, she would thank God for her
deliverance, make a garden, and find something to preserve" (29). Mrs.

Bergson's "habit" is thus cast not as stubborn and mindless adherence to routine, but as a love for plenty and order that preserves her family. In the fruit trees that she sets out, Mrs. Bergson comforts both herself and her family with the familiar foods of home; in the "few tough zenias and marigolds" that border her garden, she creates beauty as well as plenty (49).

When Alexandra has become a prosperous farmer, her own land bears witness to her mother's influence. Her farm is not only prosperous, but beautiful: "On either side of the road . . . stood tall osage orange hedges, their glossy green marking off the yellow fields. South of the hill, in a low, sheltered swale, surrounded by a mulberry hedge, was the orchard, its fruit trees knee-deep in timothy grass." Cather attributes the farm's "unusual trimness and care for detail" to the farmer's gender: "Any one thereabouts would have told you that this was one of the richest farms on the Divide, and that the farmer was a woman . . ." (83). While the Bergson boys begrudge their mother the buckets of water for flowers and fruit trees that she carries after sundown in order to avoid their censure, Alexandra maintains her mother's legacy. Ironically, the sons, when they are grown with farms of their own, come to Alexandra's house to pick cherries, neither of them having had the patience to grow an orchard. The Swedish girls whom Alexandra hires to do her housekeeping take Mrs. Bergson's place in the kitchen as they "pickle and preserve all summer long" (84). Although John Bergson "had made but little impression upon the wild land he had come to tame," the same cannot be said of his wife, whose love of plenty and order are perpetuated in her daughter's farm (20).

In Cather's *O Pioneers!,* as in Jewett's *Pointed Firs,* nature serves as a central metaphor for the spiritual realm. As a young girl, Alexandra seems to her friend Carl to have emerged from both the natural and spiritual worlds:

> He could remember exactly how she looked when she came over the close-cropped grass, her skirts pinned up, her head bare, a bright tin pail in either hand, and the milky light of the early morning all about her . . . she looked as if she had walked straight out of the morning itself. (126)

Alexandra, too, refers to herself in terms of the natural world; when her brothers accuse her of being "hard" toward them, she retorts, "If you take even a vine and cut it back again and again, it grows hard, like a tree" (171). Like Gertie Nevels, Alexandra admires and draws strength from nature's order. Watching the stars, she thinks "of their vastness and distance, and of their ordered march. It fortified her to reflect upon the great operations of nature, and when she thought of the law that lay behind them, she felt a sense of personal security" (70–71).

As she admires nature's beauty, Alexandra feels a growing kinship with the earth:

> She had never known before how much the country meant to her. . . . She had felt as if her heart were hiding down there, some-where, with the quail and the plover and all the little wild things that crooned or buzzed in the sun. Under the long shaggy ridges, she felt the future stirring. (71)

For Alexandra, the land is thus cast not as the cruel enemy that hastens her father's death and causes the bitterness in her friend Carl's face, but as a sympathetic ally.

Cather develops her notion of nature as a manifestation of the spiritual world in the character of Ivar, Alexandra's eccentric neighbor. Termed a madman by Alexandra's brothers, Ivar practices a sort of alternative religion which springs from his intimate relationship with the land. Although he "[can] not get on with any of the denominations," Ivar nonetheless observes Sunday by donning a clean shirt and reading from the Norwegian Bible (37); like Gertie Nevels, he memorizes passages that speak of God's presence in the hills and stars, the trees and animals. A vegetarian, Ivar maintains the same sympathetic relationship with animals and with humans, referring to both friends and farm animals as "sister."

In a variety of ways, Cather's text legitimates Ivar's unorthodox religious views. Like Mrs. Bergson's gardening, Ivar's spiritual beliefs are linked to traditions from their shared homeland. "You believe that every one should worship God in the way revealed to him," he tells Alexandra.

> "But that is not the way of this country. . . . At home, in the old country, there were many like me, who had been touched by

God, or who had seen things in the graveyard at night and were
different afterward. We thought nothing of it, and let them alone.
But here, if a man is different in his feet or in his head, they put
him in the asylum." (92–93)

Ivar's horror of guns, which stems from his reverence for all life, fore-
shadows the novel's central tragedy; it is he who finds Frank Shabata's
gun and the bodies of the two young lovers after Emil and Marie have
been killed. When Ivar defends his animal-like dwelling, saying that his
Bible "seemed truer to him there," Cather's narrator interrupts to voice
agreement: "If one stood in the doorway of his cave, and looked off at
the rough land, the smiling sky, the curly grass white in the hot sun-
light; if one listened to the rapturous song of the lark, the drumming
of the quail, the burr of the locust against that vast silence, one under-
stood what Ivar meant" (38).

While her brothers and neighbors mock Ivar, Alexandra clearly
admires him, not only sheltering and defending him, but also turning
to him for advice on farming matters. When Ivar confesses his fear that
her brothers will have him committed to an asylum, Alexandra voices
her affinity with him: "Like as not they will be wanting to take me to
Hastings because I have built a silo," she comforts (94). Ivar's spiritual
"madness"—his visions and unorthodox religious observances—are
thus equated with Alexandra's "madness" as a farmer. Because almost
all of Alexandra's innovations, once thought "mad," lead to her suc-
cess, Ivar's spiritual vision is thus affirmed. Ivar's example alone, how-
ever, like that of Alexandra's father, provides an insufficient model for
the gardener-farmer; by failing to develop his land, Ivar loses it.
Alexandra must thus develop her own path, using Ivar's spiritual legacy
as well as the legacies of both of her parents.

It is Alexandra's awareness of the connection between the land
and the spiritual world that leads her to see the wilderness not as an
enemy, but as an ally. Her awakening to the "Genius of the Divide"
marks both her spiritual epiphany and the point at which she emerges
as a successful farmer:

For the first time, perhaps, since that land emerged from the waters
of geologic ages, a human face was set toward it with love and
yearning. It seemed beautiful to her, rich and strong and glorious.

. . . Then the Genius of the Divide, the great, free spirit which breathes across it, must have bent lower than it ever bent to a human will before. (65)

It is thus by learning to cultivate the land without conquering it that Alexandra achieves both prosperity and self-sufficiency; the "great spirit of the Divide" must be made to bend, rather than break.

In Harriette Arnow's *The Dollmaker,* as in Cather's *O Pioneers!,* nature serves as a central metaphor for the spiritual realm. Gertie Nevels' "foundation," she declares, is "not God but what God had promised Moses—land" (128). Here too, however, it is a domesticated nature, rather than the untamed wilderness, that embodies spirituality. Gertie's "little piece a heaven right here on earth" is the Tipton Place, the farm that she longs to buy. Like Mrs. Blackett's Green Island home, the Tipton Place is represented in terms that suggest both domestic order and spiritual transcendence. Arnow describes the house, with the steam of melting frost rising from its roof in the morning sun, as "bathed in a golden halo" (53):

> The grass, the golden flowers by the house wall, the moss on the roof, the yellow chrysanthemums by the gray stepping-stones, all glowed warmly as if they, with the house on the sheltered southern hillside, were set in some land that was forever spring. (56)

As she prepares to buy her farm, Gertie compares herself to the godly woman from Proverbs: "So many times she'd thought of that other woman, and now she was that woman: 'She considereth a field and buyeth it; with the fruit of her own hands she planteth a vineyard'" (112). Gertie Nevels' deepest spiritual longings are thus cast in terms of a nature tamed by farming and domestic order.

The encroachment of the "war effort" into her rural community forces Gertie to abandon her dream of owning a farm, and Arnow consistently describes all manifestations of the war as antagonistic to nature and to human lives. In the dramatic scene in which Gertie saves her youngest son's life, the war is clearly to blame for Amos's brush with

death; Gertie is out on the main road, seeking a ride into town, because the doctor closest to her home has been called to serve in the army. The heartless army officer who refuses to help her is depicted as barely human: his face is "straight and neat and hard-appearing as [his] cap" (10), and he speaks not with a man's voice, but "with the voice of polished leather and pistol handle" (12). Gertie, by contrast, acts on behalf of human life, using her whittling knife to perform a makeshift tracheotomy in order to prevent her son from choking to death. Gertie's opposition to the war is evidenced when, even as she whittles a tiny pipe to place in Amos's open throat, she stops to cut down a recruiting poster luring people north to work in the war factories. Gertie's knife—the source of her artistry as a woodcarver—is thus associated with her life-giving power, both as she saves Amos and as she "saves" her community from the work of war.

The war threatens human life not only directly, in the killing overseas, but indirectly, by disrupting farming communities. As she talks with the soldiers, Gertie reveals that her brother, recently killed in action, had been one of the small farmers recruited by the army. For Gertie, her brother's death is manifested in his abandoned fields: "Kilt in action . . . These same leaves was green when they took him—an he'd planted his corn. Some of it he saw come up" (22). Similarly, as they drive by a poor-looking house on a small hillside farm, Gertie recognizes the signs of a husband and father gone to war: a clearing "not half tended," small fodder shocks made by a woman, a too-small child carrying wood for the stove. War is thus cast as a disruption of domestic order and farming life which threatens not only those in service, but also their wives and children.

Unlike the hero of the wilderness quest, whose relationship to nature is frequently one of conquering and subduing, Gertie as farmer is described in terms of cooperation with nature. As she walks around the Tipton Place, she speaks aloud as she cuts away underbrush, "whispering to it, laughing a little. 'Jist you wait till I git started. Away you'll all have to go to make way fer my grass an clover an corn'" (136). When choosing a tree to cut down in order to make saw handles and a maul, she bypasses several, leaving one behind for nuts for "th squirrels an my youngens," another because in a year or two it will be large enough to

provide lumber for her new barn (137). She finally chooses one dam-
aged by "some winter weight of snow, some accident with man or ani-
mal or weather . . . so that it could never grow into a fine upstanding
tree" (137). As a gardener-farmer, Gertie recognizes her interdepen-
dence with the earth and uses its resources without destroying it. These
resources are then employed in the service of domesticity: sitting down
to dinner with her children, Gertie "served it up with pride, for every-
thing, even the meal in the bread, was a product of her farming" (91).
Gertie's harmonious relationship with the land is thus intimately tied
to caring for her children.

Gertie's religious beliefs also emerge from her relationship with
the land. For Gertie, God is found not in a distant heaven, but in nature:
"A body don't have to go to Jesus," she tells her daughter Cassie. "He's
right down here on earth all th time" (76). Gertie's memories of her
brother, too, express this religious vision. As she looks out over hills
and sky,

> for an instant it seemed that her Christ, the Christ she had wanted
> for Henley was there, ready to come singing down the hill, a
> laughing Christ uncrowned with thorns and with the scars of the
> nail holes in his hands all healed away; a Christ who had loved
> people, had liked to mingle with them and laugh and sing the way
> Henley had liked people and singing and dancing. (64)

When the inheritance Henley leaves her enables her to buy the Tipton
Place, Gertie usurps biblical language to describe his sacrificial death:
"Now there was little left of him but the lonesomeness in her insides and
the land his blood had helped to buy. . . . It was as if the war and Henley's
death had been a plan to help set her and her children free so that she
might live and be beholden to no man, not even to Clovis" (139).

Gertie's religious vision, however, conflicts with her community's
fundamentalist religion, embodied by her mother. In contrast to Gertie,
strong and brown-skinned from her outdoor work, her mother is weak
and sickly, with a face "pale beyond any face she knew, almost never
touched by sun or wind, seeming always close to death and God" (61).
While Gertie's religious faith is manifested in her farming, her mother's
is appropriately reflected in her collection of potted plants: "Many were

blooming, but in a sad, halfhearted way, as if they were tired of the red clay pots, tied with crepe paper, that cramped their roots like too tight shoes" (66). When Gertie's mother gives her a cutting from a potted fern, she immediately plants it outside near the creek "where it belonged to be" (67). Significantly, when describing the enforced church-going of Gertie's childhood, Arnow also focuses on the "too tight shoes" which, along with her other Sunday dress, made the torture of Sunday services "a greater agony than any pain she had ever known" (69). The source of Gertie's spirituality is located not in church, but outdoors "where it belonged to be."

Closely tied as she is to the natural environment, Gertie consistently finds separation from nature disorienting. When she takes Amos to the doctor's office in town, she describes being confined in the windowless examination room as being "buried alive" (36). Even when she escapes briefly into the dark night, Gertie finds that the bright lights of town obscure familiar landmarks: "She tried an instant to look into the sky to find the north star and so find herself, but the lights were bright and the clouds an even gray so that as she sat on the top porch step and drank her coffee she knew not where she was" (38). This scene prefigures the family's move to Detroit, when Gertie finds herself living in "a world not meant for people" (168).

Gertie's bleak future in Detroit is foreshadowed by a series of warnings about the cost of being cut off from the land. Her son Reuben, who had shared his mother's dream of owning the Tipton Place, looks at her with contempt when he finds that she "would not speak up for their farm" (143). In the train station in Detroit, Gertie meets a woman from Tennessee who has been disillusioned and broken by her family's displacement in the northern city. She urges Gertie to return with her to Kentucky, reminding her, "It'll be gardenen time afore you know it, back home." Gertie, however, rejects the woman's warning, telling her, "Mebbe I'll have a good garden patch up here—if we stay till spring" (160). Even the harshly cynical cab driver who delivers the Nevels family to their new home mocks their dream of returning to Kentucky with enough money to buy a farm, although none of them have spoken of it. "Mama's crazy after land uv her own," Clytie cries

in surprise. "How'd you know?" (166) The Nevels family's displacement is thus cast as an abandonment of garden and farm, their subsequent physical and spiritual deterioration in Detroit a consequence of their separation from the natural world.

Gertie's displacement in Detroit is expressed largely in terms of alienation from nature: industrial pollution blots out the stars, produce is bought from vendors rather than harvested, and city water, "purified" with chemicals, comes from a tap rather than a mountain spring. Gertie's eventual reconciliation with her community and, consequently, with her own spiritual vision, coincides with the arrival of spring in the alley and the efforts of all of her neighbors to make things grow in the poor soil. As Gertie slowly emerges from the paralyzing depression that has engulfed her since Cassie's death, she feels "ashamed" at finding that she is "the only woman in the alley who ha[s] no growing thing" (447). As she follows her neighbors' example by planting flowers in her yard, she comes to realize her kinship with the women in the alley as they share the task of preserving and nurturing a communal life threatened by poverty, violence, and war. Like the women gardeners of Kolodny's study, Arnow's displaced gardeners survive their harsh new environment —a world which, like the American frontier, is defined by men—by creating domesticated spaces within it.

In *The Bluest Eye,* Toni Morrison uses gardening as a central metaphor for the potential of human growth. Morrison structures her novel around the four seasons, and the lives of her characters are intertwined with the natural world. In the winter, plagued with worry over keeping the house warm, Mr. MacTeer's face becomes winter itself:

> His eyes become a cliff of snow threatening to avalanche; his eyebrows bend like black limbs of leafless trees. His skin takes on the pale, cheerless yellow of winter sun; for a jaw he has the edges of a snowbound field dotted with stubble; his high forehead is the frozen sweep of the Erie, hiding currents of gelid thoughts that eddy in darkness. (52)

While the father is obsessed with keeping winter's cold at bay, spring, with its promise of gardens, forms the focus of Claudia and Frieda MacTeer's deepest longings. The children themselves, like dormant seeds, wait impatiently for the chance to grow and thrive: "We always responded to the slightest change in weather. . . . Long before seeds were stirring, Frieda and I were scruffing and poking at the earth, swallowing air, drinking rain . . ." (54). For Morrison's urban African-Americans, gardening and other domestic activities signal the hope for an escape to a better life. The threat of being "outdoors" is constant:

> Knowing there was such a thing as outdoors bred in us a hunger for property, for ownership. The firm possession of a yard, a porch, a grape arbor. Propertied black people spent all their energies, all their love, on their nests. Like frenzied, desperate birds, they over-decorated everything; fussed and fidgeted over their hard-won homes; canned, jellied, and preserved all summer to fill the cupboards and shelves; they painted, picked, and poked at every corner of their houses. And these houses loomed like hothouse sunflowers among the rows of weeds that were the rented houses. (18)

While gardens in the lives of the MacTeer children represent potential, for Pecola Breedlove they represent the failure of potential. *"Quiet as it's kept, there were no marigolds in the fall of 1941,"* Morrison's epigraph reads (9); the novel's central metaphor thus traces the mystery of the failed marigolds, linked as it is to Pecola's failure to thrive. Just as living, stirring seeds represent Claudia and Frieda's potential to grow and thrive, the lifeless marigold seeds symbolize Pecola's stunted growth. "[T]he land of the entire country was hostile to marigolds that year," Claudia explains. "This soil is bad for certain kinds of flowers" (160). The "soil" into which Pecola's life is planted is not, however, a rich and nurturing environment of domestic care, but a household depleted by poverty and violence.

For Claudia and Frieda, as for Mrs. Todd, the growth of plants is associated with conjuring—with the ability to call forth spiritual forces. The children learn of Pecola's pregnancy while trooping in and out of their neighbors' kitchens selling seed packets. Wanting to help their friend, they decide to plant the seeds rather than sell them, as a sort of

offering to God to save Pecola's baby: "And when they come up, we'll know everything is all right" (149). Unlike Mrs. Todd's conjuring, however, the MacTeer children's conjuring fails; everything will not be "all right" for Pecola. Morrison extends her gardening metaphor by revealing that Pecola spent her "tendril, sap-green days" deteriorating into madness (158). Just as domestic order could not overcome the poverty and violence that pervaded Pauline Breedlove's life, however, neither can the ritual planting of flowers offset the cruelties of her daughter's environment. While the MacTeer children thrive like flowers under their parents' watchful care, Pecola is left "picking and plucking her way between the tire rims and the sunflowers, between Coke bottles and milkweed, among all the waste and beauty of the world" (159).

The fictional community which Gloria Naylor creates in *Mama Day* is, in many ways, a mythic wilderness. A coastal island situated just between South Carolina and Georgia, Willow Springs belongs to no state and is connected to the mainland only by a fragile bridge. Like Jewett's Dunnet Landing, Willow Springs is a mythic landscape that transcends both time and space. Time seems to stand still here; those who die simply "fade off into the surrounding oaks and the mist coming up from the Sound" (161). Like Dunnet Landing, too, Willow Springs is no wilderness, but a domesticated space presided over by a wise woman who employs the natural world in the service of her healing powers. In this cultivated version of wilderness, the domestic and the wild, the physical and the spiritual worlds are intertwined.

Naylor portrays Miranda "Mama" Day, the conjure woman who presides over Willow Springs, as a woman whose natural gifts as a healer spring from her instinctive closeness to the earth. Miranda's familiarity with the woods is an inheritance from her father; when, as a child, she tripped over a root or was scratched by a bramble, her father instructed, *"[T]he woods been here before you and me, so why should they get out your way—learn to move around 'em"* (78). As a result, Miranda's intimate knowledge of the woods becomes second nature:

> she'd walk through in a dry winter without snapping a single twig,
> disappear into the shadow of a summer cottonwood, flatten her-
> self so close to the ground under a moss-covered rock shelf, folks
> started believing John-Paul's little girl became a spirit in the
> woods. (79)

Miranda's intimacy with the natural world is thus cast as a spiritual gift;
in the forest, she knows not only "every tree that falls," but "those that
are about to sprout" (117).

Mama Day's power as a conjurer lies not only in her knowledge of
plants, but also in her understanding of human nature—what she terms
"mother-wit" (97). When a young bride will not heed her advice—that
time and patience are all that she needs in order to become pregnant—
Miranda devises a "remedy," dying pumpkin seeds and giving Bernice
strict instructions about when to plant them. When Miranda's sister
Abigail protests, "Bernice gonna know they're nothing but pumpkin
seeds," Miranda replies, "Bernice is gonna believe what I tell her they
are—magic seeds. And the only magic is that what she believes they are,
they're gonna become" (96). Miranda is thus a practitioner not only of
herbal medicine, but of what Sara Ruddick terms "connected knowing,"
which examines "the circumstances in which a person comes to believe
. . . This way of knowing requires a patient sympathetic listening to the
complexities and uncertainties of another's experience" (95–96). As both
conjurer and mother figure, Miranda thus responds empathically to
Bernice, understanding and using her passionate desire for a child in order
to help her.

In *Mama Day,* gardening and farming, as well as conjuring, are
depicted as sacred occupations which spring from an intimacy with the
earth. Naylor portrays Ambush Duvall, a truck farmer on the island, as
a man of "infinite patience":

> Walking with Ambush through his fields was to watch the hand
> of a virtuoso stroke the instrument of his craft. An absentminded
> handful of soil worked between his fingers as the endless rows
> melted into the blurred outlines of the horizon. The weight, the
> texture, the smell telling him of possibilities I couldn't begin to
> understand. In the fading light it could have been his own skin
> flaking off gently into the ground. (200)

Naylor thus creates so sympathetic a relationship between the farmer and the land that the distinction between the two is blurred. When a hurricane ravages the island, Mama Day walks through her garden, "ankle deep in leaves and broken branches," to assess the storm's damage: "crumbling a fistful of earth and then licking at her fingers, she knows there's reason for hope" (254). A garden that can be salvaged thus signifies hope in the storm's aftermath.

While the quest myth depicts the wilderness as a place set apart from family and community, in *Mama Day* the forest links people with their ancestors. To walk through the woods to the "other place," the family homestead, is to travel back in time to the origins of the Day family. Here, as in Helen Levy's description of the "home place," there is little distinction between house, garden, and wilderness: "the house belonged to the garden engulfing it on four sides and there was little difference between that garden and the woods that stopped at the front gate" (225). When she walks through the family graveyard, Miranda stops to put a bit of hanging moss into her shoes, a ritual which makes the voices of the ancestors audible to her. The natural world thus serves not as an escape from family ties, but as a bridge connecting the living and the dead, the physical and the spiritual.

Throughout *Mama Day,* Naylor depicts the natural and human worlds as intimately intertwined. An abundance of butterflies signifies a "good summer" of economic prosperity: "Drumfish and mullet ain't waiting to be hooked, they're jumping into the boats. Crawdaddies and oysters are a dime a hundred and crabs are coming up as big as two hands. Nobody's sick. Everybody's working. Gardens are doing so well it's ridiculous" (148). The natural world, rather than functioning as a separate sphere detached from human concerns, offers signs and warnings to be followed: "[S]ea life, birds, and wood creatures, they got ways just like people," Mama Day tells George. "'Cepting they live in the sky, the earth, the tides. So who better to ask about their home? You just gotta watch 'em long enough to find out what's going on" (207). Chaos in the natural world, too, portends chaos in the human realm. When a racist deputy from the mainland humiliates a Willow Springs man by calling him "nigger," Mama Day predicts, "You'll learn to address him proper before the night is over." That night brings not only

human revenge—slashed tires on the deputy's car—but nature's revenge—"one of the worst lightning storms in a decade" (80). Similarly, when a woman's hatred and jealousy lead her to put a curse on Miranda's niece, her house is struck and burned by lightning. The wilderness, while it is a transcendent realm, is nonetheless intimately connected to the concerns of the living.

In Naylor's Willow Springs, the earth's abundance provides for both the physical and spiritual needs of its inhabitants. The yearly ritual of Candle Walk, for example, serves a dual function, providing connection to the dead while serving the physical needs of the living. Although none of the island's inhabitants can remember why they all walk on the main road every December 22, carrying lights and exchanging gifts, young and old continue the tradition because it connects them to an ancient past: "It's been going on since before they were born and the ones born before them" (110). As important as the ritual greeting—"Lead on with light"—is the exchange of food gifts. While for some this is a token exchange of ginger cookies or scented pomander balls, for others it fills the void left by a poor crop yield:

> Candle Walk was a way of getting help without feeling obliged
> . . . them that needed a little more got it quiet-like from their
> neighbors. And it weren't no hardship giving something back—
> only had to be a bit of something, as long as it came from the earth
> and the work of your own hands. A bushel of potatoes and a cured
> side of meat could be exchanged for a plate of ginger cookies, or
> even a cup of ginger toddy. (110)

Gifts from the earth thus sustain the community both physically and spiritually. Miranda's gifts to her niece, Cocoa, also function to sustain both body and spirit. While Cocoa lives in New York and visits Willow Springs only once a year, Miranda sends her back with abundant gifts from the earth: canned preserves, potpourri, and supplies of her herbal remedies. Like the gardens of Mrs. Todd and Gertie Nevels, Alice Walker's mother and Miranda Day, these gifts enact a sustaining connection between the natural world and human lives.

Chapter VI

Conclusion:
The Wilderness Within

i found god in myself
& i loved her / i loved her fiercely
—Ntozake Shange

The questions at the center of this study concern the construction of meaning: How do psychology, theology, and literature converge to shape our understanding of the spiritual realm? And how do these constructs both *allow* us to see and *prevent* us from seeing the spiritual concerns expressed by writers of fiction? The psychological, theological, and literary studies discussed here deconstruct the quest as the central symbol for spiritual experience in American literature by examining the cultural roots of the quest in both male psychological development and patriarchal Western theology. Feminist studies propose alternative spiritual constructs which become possible when the lives of women, rather than men, are the subject.

Western theology has traditionally characterized spiritual development as a linear journey, away from home and community and toward wilderness, individual achievement, and autonomy. As feminist theologians including Rosemary Ruether, Carol Ochs, and Naomi Goldenberg make clear, however, the quest as a model for spiritual development reflects not a universal spiritual truth, but a paradigm based on the psychological and cultural development of men. According to studies in psychology, sociology, and education by Jean Baker Miller, Carol Gilligan, Sara Ruddick, and others, many women both perceive

and speak of their lives as being part of a network of interdependent rela-
tionships, rather than a lone, linear journey. Similarly, feminist theo-
logians suggest that women's spiritual development is expressed in terms
of increased engagement with the everyday world, particularly the realms
of home and community, rather than in terms of increased separation.
Both psychology and theology thus cast not the lone journey, but com-
ing into relationship, as the central experience of female development.

What is perhaps even more problematic about the journey motif
than its exclusion of women, however, is its archetypal status. In *Changing
of the Gods,* Naomi Goldenberg names the "archetyping" of religious
images as a form of stereotyping; "The archetype becomes the functional
equivalent of 'God's will,' which it is quite hopeless and downright
immoral to fight" (61). By rendering this myth a universal model of spir-
itual development, theologians have ignored the cultural and historical
factors that shape our understanding of ourselves and of the spiritual
realm. In contrast to traditional Western theology, feminist theology
views human experience as authoritative in shaping spiritual under-
standing. Rather than attempting to mold their understanding of the
divine to fit religious archetypes, feminist theologians reject those
archetypes that do not reflect their experiences in the world. By view-
ing their own experiences as authoritative, feminist theologians make
possible new models and new patterns for spiritual experience.

As Goldenberg warns, however, substituting archetypes based on
women's experience merely repeats the mistakes of patriarchal theol-
ogy by suggesting that spiritual experience must be manipulated to fit
the images available to represent it. Rather, Goldenberg suggests,

> Each fantasy, dream or life story could be classified by the impact
> it carries for our lives, our communities and the times of our his-
> tory. We could begin to understand that what binds us together
> as human beings is not, in fact, the *contents* of our religious and
> psychic imagery but rather the continual *process* of producing and
> reflecting on imagery. (64)

In discussing domesticity, community, and other facets of women's fic-
tion as spiritual realms which offer alternatives to the quest motif, I am
therefore not suggesting that these be adopted as archetypes of women's

experience. Rather, I am proposing that to view religious constructs as emerging out of specific historic and cultural contexts opens up the possibility for viewing other experiences, in literature and in life, as enactments of the spiritual realm.

Literature, like psychology and theology, employs archetypes to construct meaning—to express the central, formative experiences of human existence. In American literature, the wilderness quest has evolved into one such archetype. As Nina Baym illustrates, however, this motif is an inaccessible one for women, who are often precluded from quest by obligations to home and community. Feminist studies in psychology and theology suggest that the quest motif is not only less accessible, but also less resonant for women, for whom relationship, rather than autonomy, is often central.

As in psychological and theological studies, however, the exclusion of women from the quest myth is less problematic than the casting of the quest itself as an archetype of universal human experience—a "megamyth," Melody Graulich writes, which becomes "a theoretical framework through which critics come to understand American culture" (186). Such "universalizing" of patterns which emerge from the lives of men obscures alternative myths which shape American literature; for, as Graulich continues, "while the frontier dream of escape to freedom *is* a significant recurring pattern in American literature, it is only one of many and has often been too widely applied in defining the essential qualities of American literature" (188). Specifically, the focus on quest as the embodiment of spiritual experience may obscure alternative patterns of spirituality to be found in texts by women writers. As Bettina Aptheker writes in *Tapestries of Life*, "[T]he quilts, the stories, the gardens, the poems, the letters, the recipes, the rituals are examples of women's ways of knowing. They mark the evidence that there is and always has been another point of view, another record of social reality, a women's standpoint. . . . Because it has not been valued, it has often not been seen, even by ourselves" (74).

What emerges most strikingly in examining women's literary constructs of spirituality as alternatives to the quest myth is that these texts consistently depict spirituality as an outgrowth of "ordinary" life. Because women traditionally provide for the needs of others, their spirituality is

expressed not in flight from those everyday concerns, but in engagement with them. Repeatedly, the literary texts discussed here portray the care of children or neighbors, the preparation of meals, the creation of a garden or a quilt as sources of spiritual transcendence. Spirituality in the lives of these women characters pervades the everyday world, "interrupting" ordinary lives through the presence of ghosts or the telling of sacred stories. In women's spirituality there emerges a seamlessness between the everyday and the spiritual, the ordinary and the transcendent.

In examining domesticity, community, and storytelling as some of the dominant metaphors through which American women writers express spirituality, it is important that the recovery of these experiences from the margins of patriarchal culture not be viewed as an idealization or romanticization of women's sphere. All aspects of women's culture arise, in part, out of women's marginal political, cultural, and economic status; thus, many women's lives and stories focus on the domestic realm because women have been denied equal access to and power within the public world. Further, several of the writers discussed in this study illuminate the limitations and even the dangers of home, community life, and storytelling as well as their potentially transformative power. Like their ancestors, however—whether the diarists and letter writers of the western frontier or the quilters and storytellers who spent their lives in slavery—women writers have frequently turned these limitations into their own sphere of creativity and spiritual expression. The garden thus serves as an apt metaphor for the spiritual seeking of female characters who find spiritual meaning not in male myths of freedom and wilderness, but in the familiar terrain of women's domestic lives.

Works Consulted

Primary Sources

Arnow, Harriette. *The Dollmaker*. 1954. New York: Avon, 1972.

Cather, Willa. *O Pioneers!* Boston: Houghton Mifflin, 1913.

Gibbons, Kaye. *Ellen Foster*. 1987. New York: Vintage, 1990.

Hurston, Zora Neale. *Their Eyes Were Watching God*. 1937. New York: Harper and Row, 1990.

Jewett, Sarah Orne. *The Country of the Pointed Firs*. 1896. New York: W. W. Norton, 1981.

Morrison, Toni. *Beloved*. New York: Plume, 1987.

———. *The Bluest Eye*. 1970. New York: Pocket Books, 1972.

Porter, Katherine Anne. *The Old Order: Stories of the South*. New York: Harcourt, Brace and World, 1958.

Walker, Alice. *The Color Purple*. 1982. New York: Pocket Books, 1983.

Secondary Sources

Ammons, Elizabeth. "Going in Circles: The Female Geography of Jewett's *The Country of the Pointed Firs*." *Studies in the Literary Imagination* 16 (1983): 83–92.

Aptheker, Bettina. *Tapestries of Life: Women's Work, Women's Consciousness, and the Meaning of Daily Experience*. Amherst: University of Massachusetts Press, 1989.

Auerbach, Nina. *Communities of Women: An Idea in Fiction*. Cambridge, Mass.: Harvard University Press, 1978.

Baym, Nina. "Melodramas of Beset Manhood: How Theories of American Literature Exclude Women Authors." *The New Feminist Criticism*. Ed. Elaine Showalter. New York: Pantheon Books, 1985. 63–80.

Belenky, Mary Field, et al. *Women's Ways of Knowing: The Development of Self, Voice, and Mind*. New York: Basic Books, 1986.

Bloom, Harold, ed. *Zora Neale Hurston*. New York: Chelsea House, 1986.

———. *Zora Neale Hurston's "Their Eyes Were Watching God."* New York: Chelsea House, 1987.

Brown, Lyn Mikel, and Carol Gilligan. *Meeting at the Crossroads: Women's Psychology and Girls' Development*. Cambridge: Harvard University Press, 1992.

Chodorow, Nancy. "Family Structure and Feminine Personality." *Woman, Culture, and Society*. Ed. Michelle Zimbalist Rosaldo. Stanford: Stanford University Press, 1974.

———. "Gender, Relation, and Difference in Psychoanalytic Perspective." *Essential Papers on the Psychology of Women*. Ed. Claudia Zanardi. New York: New York University Press, 1991. 420–36.

———. *The Reproduction of Mothering: Psychoanalysis and the Sociology of Gender*. Berkeley: University of California Press, 1978.

Christ, Carol. *Diving Deep and Surfacing: Women Writers on Spiritual Quest*. Boston: Beacon Press, 1980.

Christian, Barbara. *Black Feminist Criticism: Perspectives on Black Women Writers*. New York: Pergamon, 1985.

———. *Black Women Novelists: The Development of a Tradition, 1892–1976*. Westport, Conn.: Greenwood, 1980.

Connor, Kimberly Rae. *Conversions and Visions in the Writings of African-American Women*. Knoxville: University of Tennessee Press, 1994.

Crabtree, Claire. "The Confluence of Folklore, Feminism, and Black Self-Determination in Zora Neale Hurston's *Their Eyes Were Watching God.*" *Southern Literary Journal* 17 (spring 1985): 54–66.

Donovan, Josephine. *Feminist Theory: The Intellectual Traditions of American Feminism*. New York: Frederick Ungar Publishing Co., 1985.

Douglas, Kelly Brown. "Teaching Womanist Theology." *Living the Intersection: Womanism and Afrocentrism in Theology*. Ed. Cheryl J. Sanders. Minneapolis: Fortress Press, 1995. 147–55.

Eliade, Mircea. *The Sacred and the Profane*. Trans. Willard R. Trask. San Diego: Harcourt Brace Jovanovich, 1987.

Epstein, Barbara. *The Politics of Domesticity*. Middletown, Conn.: Wesleyan University Press, 1981.

Faderman, Lillian. *Surpassing the Love of Men: Romantic Friendship and Love between Women from the Renaissance to the Present.* New York: William Morrow, 1981.

Gergen, Mary. "Life Stories: Pieces of a Dream." *Storied Lives: The Cultural Politics of Self-Understanding.* Ed. George C. Rosenwald and Richard L. Ochberg. New Haven: Yale University Press, 1992. 127–44.

Gilligan, Carol. *In a Different Voice: Psychological Theory and Women's Development.* Cambridge, Mass.: Harvard University Press, 1982.

———. "Remapping the Moral Domain: New Images of the Self in Relationship." *Essential Papers on the Psychology of Women.* Ed. Claudia Zanardi. New York: New York University Press, 1991. 480–95.

Goldenberg, Naomi. *Changing of the Gods: Feminism and the End of Traditional Religions.* Boston: Beacon Press, 1979.

Graulich, Melody. "'O Beautiful for Spacious Guys': An Essay on the 'Legitimate Inclinations of the Sexes.'" *The Frontier Experience and the American Dream: Essays on American Literature.* Ed. David Mogen, Mark Busby, and Paul Bryant. College Station: Texas A & M University Press, 1989. 186–201.

Gray, Elizabeth Dodson. *Sacred Dimensions of Women's Experience.* Wellesley, Mass.: Roundtable Press, 1988.

Grigg, Richard. *When God Becomes Goddess: The Transformation of American Religion.* New York: Continuum, 1995.

Harris, Trudier. "From Exile to Asylum: Religion and Community in the Writings of Contemporary Black Women." *Women's Writing in Exile.* Ed. Mary Lynn Broe and Angela Ingram. Chapel Hill: University of North Carolina Press, 1989. 151–69.

———. *From Mammies to Militants: Domestics in Black American Literature.* Philadelphia: Temple University Press, 1982.

Holloway, Karla F. C. "*Beloved:* A Spiritual." *Callaloo* 13 (1990): 516–25.

———. *The Character of the Word: The Texts of Zora Neale Hurston.* New York: Greenwood Press, 1987.

———. *Moorings and Metaphors: Figures of Culture and Gender in Black Women's Literature.* New Brunswick, N.J.: Rutgers University Press, 1992.

Holloway, Karla F. C., and Stephanie A. Demetrakopoulos. *New Dimensions of Spirituality: A Biracial and Bicultural Reading of the Novels of Toni Morrison.* New York: Greenwood Press, 1987.

Kerber, Linda K., et al. "On *In a Different Voice:* An Interdisciplinary Forum." *Signs* 11 (winter 1986): 304–33.

Kolodny, Annette. *The Land Before Her: Fantasy and Experience of the American Frontiers, 1630–1860*. Chapel Hill: University of North Carolina Press, 1984.

———. *The Lay of the Land: Metaphor as Experience and History in American Life and Letters*. Chapel Hill: University of North Carolina Press, 1975.

Lawrence, David. "Fleshly Ghosts and Ghostly Flesh: The Word and Body in *Beloved*." *Studies in American Fiction* 19 (fall 1991): 189–201.

Levy, Helen F. *Fiction of the Home Place: Jewett, Cather, Glasgow, Porter, Welty, and Naylor*. Jackson: University Press of Mississippi, 1993.

Lewis, R. W. B. *The American Adam: Innocence, Tragedy and Tradition in the Nineteenth Century*. Chicago: University of Chicago Press, 1955.

Lorber, Judith, Rose Laub Coser, Alice S. Rossi, and Nancy Chodorow. "On *The Reproduction of Mothering*: A Methodological Debate." *Signs* 6 (1981): 482–514.

May, Rollo. *The Cry for Myth*. New York: W. W. Norton, 1991.

McKay, Nellie Y., ed. *Critical Essays on Toni Morrison*. Boston: G. K. Hall, 1988.

Mednick, Martha T. "On the Politics of Psychological Constructs: Stop the Bandwagon, I Want to Get Off." *American Psychologist* 44 (1989): 1118–23.

Miller, Jean Baker. "The Development of Women's Sense of Self." *Essential Papers on the Psychology of Women*. Ed. Claudia Zanardi. New York: New York University Press, 1990. 437–54.

———. *Toward a New Psychology of Women*. Boston: Beacon Press, 1976.

"Miss Jewett's *A Marsh Island*." *Critical Essays on Sarah Orne Jewett*. Ed. Gwen L. Nagel. Boston: G. K. Hall, 1984. 33–34.

Mobley, Marilyn Sanders. *Folk Roots and Mythic Wings in Sarah Orne Jewett and Toni Morrison: The Cultural Function of Narrative*. Baton Rouge: Louisiana State University Press, 1991.

Mogen, David, Mark Busby, and Paul Bryant, eds. *The Frontier Experience and the American Dream: Essays on American Literature*. College Station: Texas A&M University Press, 1989.

Morey, Ann-Janine. *Religion and Sexuality in American Literature*. Cambridge: Cambridge University Press, 1992.

Nagel, Gwen L., ed. *Critical Essays on Sarah Orne Jewett*. Boston: G. K. Hall, 1984.

Ochs, Carol. *Women and Spirituality*. Totowa, N.J.: Rowman and Allanheld, 1983.

Pennell, Melissa McFarland. "A New Spiritual Biography: Domesticity and Sorority in the Fiction of Sarah Orne Jewett. *Studies in American Fiction* 18 (1990): 193– 206.

Porterfield, Amanda. *Feminine Spirituality in America: From Sarah Edwards to Martha Graham.* Philadelphia: Temple University Press, 1980.

Pratt, Annis. *Archetypal Patterns in Women's Fiction.* Bloomington: Indiana University Press, 1981.

Pryse, Marjorie. "Zora Neale Hurston, Alice Walker, and the 'Ancient Power' of Black Women." *Conjuring: Black Women, Fiction, and Literary Tradition.* Ed. Marjorie Pryse and Hortense J. Spillers. Bloomington: Indiana University Press, 1985.

Rabuzzi, Kathryn Allen. *The Sacred and the Feminine: Toward a Theology of Housework.* New York: Seabury Press, 1982.

Randour, Mary Lou. *Women's Psyche, Women's Spirit: The Reality of Relationships.* New York: Columbia University Press, 1987.

Renza, Louis A. *"A White Heron" and the Question of Minor Literature.* Madison: University of Wisconsin Press, 1984.

Rigney, Barbara Hill. *The Voices of Toni Morrison.* Columbus: Ohio State University Press, 1991.

Roman, Margaret. *Sarah Orne Jewett: Reconstructing Gender.* Birmingham: University of Alabama Press, 1992.

Romines, Ann. *The Home Plot: Women, Writing and Domestic Ritual.* Amherst: University of Massachusetts Press, 1992.

Rosenwald, George C., and Richard L. Ochberg, eds. *Storied Lives: The Cultural Politics of Self-Understanding.* New Haven: Yale University Press, 1992.

Ruddick, Sara. *Maternal Thinking: Toward a Politics of Peace.* Boston: Beacon Press, 1989.

Ruether, Rosemary. *Sexism and God-Talk: Toward a Feminist Theology.* Boston: Beacon Press, 1983.

Sanders, Cheryl J. "Afrocentric and Womanist Approaches to Theological Education." *Living the Intersection: Womanism and Afrocentrism in Theology.* Ed. Cheryl J. Sanders. Minneapolis: Fortress Press, 1995. 157–75.

Smith, Henry Nash. *Virgin Land: The American West as Symbol and Myth.* 1950. New York: Vintage Books, 1961.

Spillers, Hortense, and Marjorie Pryse. *Conjuring: Black Women, Fiction, and Literary Tradition.* Bloomington: Indiana University Press, 1985.

Tavris, Carol. *The Mismeasure of Woman*. New York: Simon and Schuster, 1992.

Trace, Jacqueline. "Dark Goddesses: Black Feminist Theology in Morrison's *Beloved*." *Obsidian II* 6(1991): 14–30.

Vrettos, Athena. "Curative Domains: Women, Healing and History in Black Women's Narratives." *Women's Studies* 16 (1989): 455–74.

Walker, Alice. *In Search of Our Mothers' Gardens*. San Diego: Harcourt Brace Jovanovich, 1983.

Washington, Mary Helen. Foreword. *Their Eyes Were Watching God*. By Zora Neale Hurston. New York: Harper and Row, 1990.

————. *Invented Lives: Narratives of Black Women, 1860–1960*. New York: Anchor Books, 1987.

Williams, David R. *Wilderness Lost: The Religious Origins of the American Mind*. Selinsgrove, Penn.: Susquehanna University Press, 1987.

Wolf, Naomi. *Fire with Fire: The New Female Power and How It Will Change the Twenty-First Century*. New York: Random House, 1993.

Woolf, Virginia. *A Room of One's Own*. San Diego: Harcourt Brace Jovanovich, 1929.

Zagarell, Sandra A. "Narrative of Community: The Identification of a Genre." *Signs* 13 (1988): 498–527.

Index